Character Trademarks

Character Trademarks

John Mendenhall

ANGUS
& ROBERTSON
PUBLISHERS

Signs and Symbols
rule the world ~
not words nor laws
— Confucius

AN ANGUS & ROBERTSON BOOK

Angus & Robertson (UK)
16 Golden Square, London, W1R 4BN
United Kingdom
Collins/Angus & Robertson Publishers Australia
Unit 4, Eden Park, 31 Waterloo Road,
North Ryde, NSW 2113, Australia
William Collins Publishers Ltd.
31 View Road, Glenfield, Auckland 10,
New Zealand

First published in the United Kingdom by
Angus & Robertson (UK) in 1991
First published in Australia by
Collins/Angus & Robertson Publishers,
Australia in 1991
First published in the United States by
Chronicle Books in 1990.

Text copyright © John Mendenhall 1990.

Printed in Japan

British Library Cataloguing in Publication Data

Character trademarks
1. Trade marks. Design
I. Mendenhall, John
602.75

ISBN 0 207 16994 2

Table of Contents

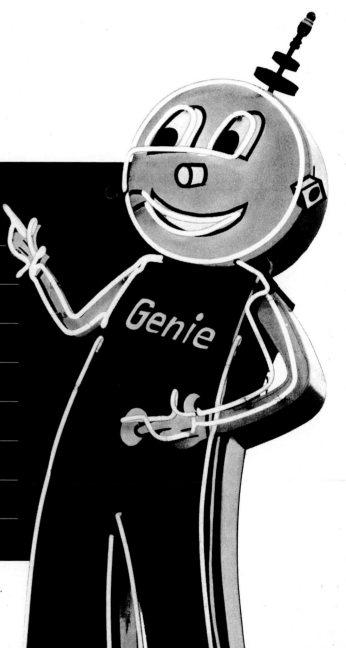

"Genie"
Genie Manufacturing, Inc.
Alliance, Ohio
Automatic garage door
openers, c. 1960

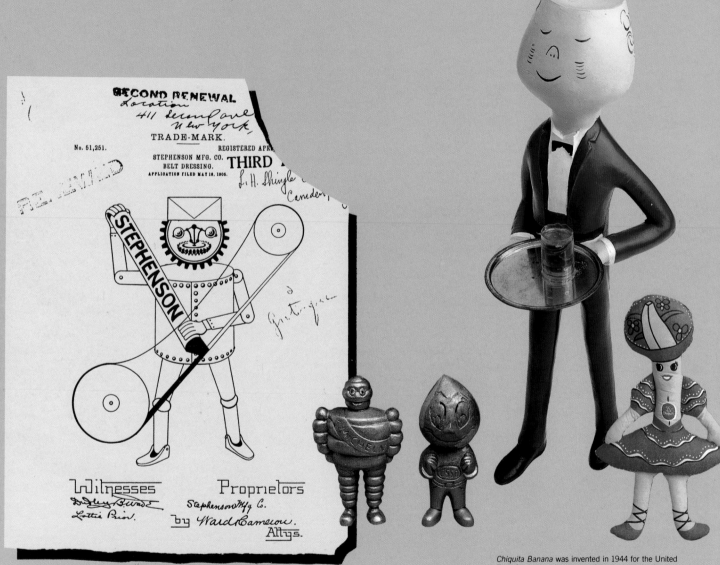

Character mark for Stephenson Manufacturing Company of New York. Shown here is the original trademark application.

These pot metal figurines of the *Michelin Man* and *Little Oil Drop* were used as molds for racing trophies in France.

Chiquita Banana was invented in 1944 for the United Fruit Company. Like many other character trade figures, she was made into a plush doll and sold as a promotional toy.

During the 1950s, sales of cognac were promoted by this slender figure of a waiter with a brandy snifter head. He appeared in print ads as well as numerous point-of-purchase displays.

Introduction

"The most sincere, hardest working sales people in the world are the nationally advertised trade characters. By their integrity they have won a position of trust and respect in the households of the nation, identifying products of known value, made by companies of unquestioned honesty."

—1928 paper company advertisement

We all have our favorite character trademarks, which conjure in our minds pleasant associations or fond memories from our youth. The character I recall best is Nipper, the RCA dog who sat patiently in front of the gramophone listening to his master's voice. A huge, three-dimensional version of him used to perch atop a shelf in my hometown record shop, where I went as a kid just about every Saturday to preview the latest 45rpms in a soundproof listening booth. I still can see the owner of the store, an elderly gentleman in a suit and bow tie, gingerly placing records on the store's turntable. He always seemed oblivious to the giant fox terrier above him, peering quizzically into the giant horn.

Those days, and the record shop, are gone forever. Even the RCA corporation has ceased to exist. Only Nipper remains, a trademark for a conglomerate now owned by the General Electric Company. Some may consider him hopelessly outdated, yet something has to be said for a dog who survives over seventy years, while all else changes so dramatically around him.

Nipper, Little Oscar, the Jolly Green Giant, Betty Crocker and others survive because character trademarks have the ability to evoke emotional responses, to stick in our memories, in a way that no abstract corporate logo can. The value of these characters is that they instill confidence in products and invoke in the mind of the consumer those all-important thoughts of trust, integrity and honesty. Faith in corporations may be shaky, but our belief in these symbols persists.

Around the turn of the century, companies started to recognize that personifying the products that they manufactured would be a valuable marketing tool. One of the earliest character trademarks to be created was Bibendum, the Michelin Man, symbol for the Michelin Tire and Rubber Company. Introduced in 1895 and fondly referred to as "Old Rubber Ribs," his design was inspired by a stack of automobile tires. Soon after, the

One of the most popular of all character trademarks, still in use nearly a century after its creation, is the *Michelin Man*. Remaining relatively unchanged from his original design, he now appears throughout Europe in three-dimensional plastic or vinyl form.

symbol for Stephenson Manufacturing Company, a maker of dressings for machinery belts, was registered with the United States Patent and Trademark Office. This 1905 character trademark consisted of a robot-like figure constructed from industrial tubing and gears.

By far the most popular personified trade characters of the 1920s were the smiling Wrigley Spearmen, animated arrows derived from the word "spearmint." Advertising William Wrigley's chewing gum in magazines, newspapers and on billboards, these ubiquitous fellows helped turn a $32.00 investment into a multimillion-dollar corporation. As one observer of the era, a trademark historian, wrote: "Trade characters such as the Spearmen are not to be ignored; in a twinkling they register their impression and its repetition conjures up active goodwill in the buyer's appetite for superior chewing gum."

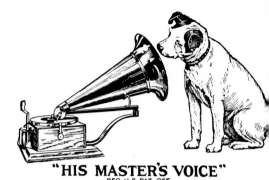

"HIS MASTER'S VOICE"
REG. U.S. PAT. OFF.

Objects given human qualities, such as the Spearmen, are referred to as anthropomorphic forms. Their human-like qualities make them more accessible, or appealing, to the viewer. Because they can take different poses and be used in a variety of publicity venues, from print to point-of-purchase displays to animated cartoons, they easily become engrained in people's minds. Mention Speedy Alka Seltzer and the singing analgesic tablet from the 1950s television commercials immediately comes to the mind of anyone who has seen him. Although he rarely appears these days, the redheaded Speedy is one of the most memorable trade characters to be created.

Man-made objects, from dollar bills to coffee cups, have been humanized and registered as trademarks over the years. Even fruits, vegetables and assorted plant forms have been personified. With top hats and canes, or even crowns, they take on regal qualities quite apart from their lowly vegetable garden origins. The 1937 Heinz Aristocrat tomato was one of the earliest vegetable success stories.

The use of animals as character marks has also been popular. We are all familiar with Mickey Mouse, Donald Duck and assorted other cartoon characters, who are essentially animals with human traits. Trademark beasts are always loveable and their unique characteristics are ideal for representing certain products. What better way to symbolize an ice company than with a penguin? Why not convey the concept of strength with a bulldog, or speed with a roadrunner? Who can't appreciate Elsie the Cow smiling back at them from their milk carton in the morning? Everyone loves at least some animals, so they make ideal messengers. The popularity of Spuds Mackenzie, the Budweiser "Party Animal" pooch, is proof of that.

Although animals and objects are common trade characters, the commonest trade characters by far are humans: men, women and children have all been called into service as trademarks. Probably the most popular and widely used trade character of all

time has been Santa Claus. Instantly recognizable and in the public domain, he is undoubtedly responsible for billions of dollars worth of sales during the Christmas season. His image has been reproduced by so many companies in so many different ways that he's become inseparable from the holiday he represents. Indeed, some may argue that his image is a more powerful marketing tool than any image that evokes the day's religious significance.

Most characters have a more modest existence. Serving small to medium-sized businesses, often appealing only to a regional audience, they promote goods and services for a vast array of enterprises. Sharin Profit advertised a profit sharing plan for years; Mr. Goodmeat acts as a mascot for, what else, a delicatessen. No one can accuse these companies of lacking a sense of humor. The play on names, the effort to evoke a smile in the viewer, are themes which weave through many character designs. These unpretentious figures are, in the truest sense of the words, user friendly.

Not created merely to grace the tops of corporate letterheads, trade characters have a remarkable ability to sell in a variety of situations. Because of this they are carefully protected by companies privy to the merchandising power they represent. Also, not all trademarks are used in the classic sense to identify source; they are often utilized today as decorations on products, from T-shirts to soft drink glasses. Counsel for Walt Disney Productions expressed it well when he said, "Mickey Mouse and his various friends are performers and salesmen who serve without pay. They work at all hours, whenever called upon. They are not temperamental and they need no union card. They need no food, no transportation, no lodging. But one thing is certain—they need a lawyer!"

The design professional is advised to suspend judgment when approaching this collection of oddball figures. They are humble, often silly, and certainly out-of-step with "mainstream" graphic design. Hooray! While corporate identity designers have been churning out an endless array of impeccably executed circles and boxes transversed by variegated lines, all souless, the creators of character trademarks have taken a different direction.

For every business that adopts some sort of geometric dingbat to represent itself, another chooses a figurative logo, or resurrects one which had been previously retired. Like urban renewal in reverse, Mobil Oil has brought back the Pegasus and NBC once again has its peacock.

We are continually reminded that as our society becomes more technological, it is also becoming more impersonal. Character trademarks resist that trend. They suggest a simpler era of neighborhood grocers and friendly repairmen. They are likeable. They are fun to look at. And they have come to represent a certain innocence with which we all, at some point in our lives, can identify.

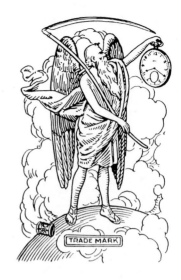

Elgin watches adopted *Father Time* as its character mark in the 1920s.

The Heinz *Aristocrat Tomato* is one of many vegetables which have been given formal attire over the years.

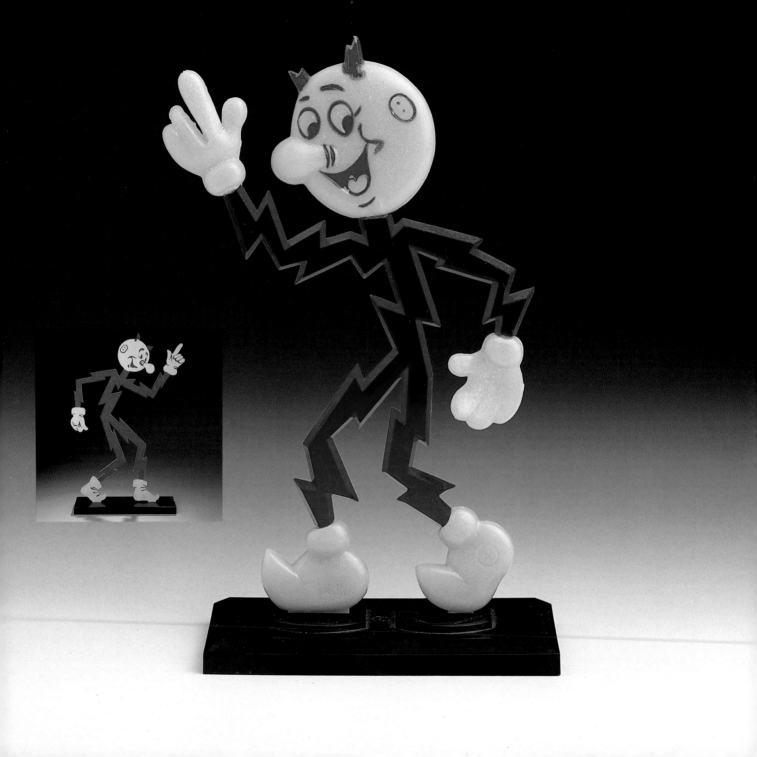

Anthropomorphic Character Marks

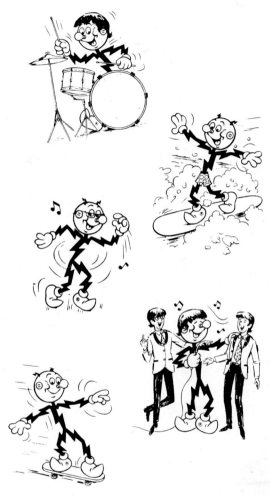

Perhaps the most endearing of all anthropormorphic characters is *Reddy Kilowatt.* The brainchild of Ash Collins, a commercial manager of the Alabama Power Company, Reddy was created in 1926 in an effort to establish an appealing personality as the symbol of electric service. Electric companies across America adopted him as a trademark. By humanizing the kilowatt, Reddy made the concept of electricity appear more warm and friendly to the residents of the communities the companies served.

Collins conceived the idea of a whimsical figure with body, arms and legs of zigzag lightning, a round head with a shining light bulb for a nose and convenience outlets for ears. It was his belief that such a figure could personify electricity by serving as a ubiquitous and versatile electric servant. Reddy was soon licensed for all aspects of power company promotion, including window displays, advertising and musical jingles tying him to the services electricity performs in the home. Mammoth press books of "clip art," showing Reddy in a variety of poses and outfits, were provided to electric companies for use in their local publicity.

Le Bon Génie de L'Electricité, the French version of Reddy Kilowatt, appeared in 1929. Numerous character marks utilizing lightning bolts or flames have since been created, all in an effort to humanize the concept of electric or gas energy. While Reddy's popularity peaked in the 1950s, he remained a trusty power company trademark until the 1970s. Having undergone a number of revisions and attempts at updating, Reddy Kilowatt has apparently "flickered out" in this modern age of nuclear power.

Over the years *Reddy Kilowatt* has been transformed into a variety of display figures, from small desk models to huge neon signs. The inset photograph is of a wood figurine made in the 1930s from Reddy's original design. The plastic figure, dated 1956, features a plumper Reddy strutting atop an electric outlet base. Appropriately, his head, hands and feet glow in the dark.

Clip-art images of *Reddy Kilowatt* during the 1960s attempted to portray him as a hip character. He was retired from use shortly thereafter.

The Lumber Man

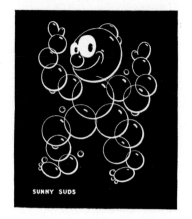

SUNNY SUDS

"Bill Ding"
Local Trademarks, Inc.
New York, New York
Advertising services, 1921

"The Lumber Man"
**Herman Hettler
Lumber Company**
Chicago, Illinois
Lumber, 1930

"Sunny Suds"
Advance Laundries Ltd.
London, England
Laundered clothing, 1938

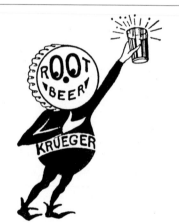

"General Caps"
General Can Company
Chicago, Illinois
Caps for bottles and jars, 1938

Krueger Beverage Company
Newark, New Jersey
Root beer, 1937

"Cappy"
The Aridor Company
Chicago, Illinois
Caps for jars, 1942

"Spud"
**The Axton-Fisher
Tobacco Company**
Louisville, Kentucky
Cigarettes, 1938

"Ace"
Chicago Lock Company
Chicago, Illinois
Locks and keys, 1940

"Sporty"
**ADEL Precision
Products Corporation**
Burbank, California
Tools, 1943

Crown Zellerbach Corporation
San Francisco, California
Tissue fruit wraps, 1944

"Ring Master"
Vevier Loose Leaf Company
St. Louis, Missouri
Loose leaf binders, 1944

National Stationery and Office Equipment Association
Washington, D.C.
Trade association, 1954

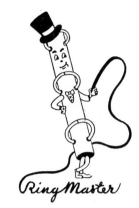

The Carborundum Company
Niagara Falls, New York
Abrasive sheets, 1945

"Mido"
Mido Watch Company
New York, New York
Self-winding watches, c. 1945

Hugo Soloman & Son, Inc.
Detroit, Michigan
Door locks and keys, 1951

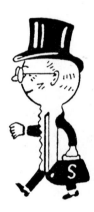

"Pica Man"
R-L-M Printing Company
Minot, North Dakota
Printing, 1949

"His Royal Nibs"
Brown Company
Portland, Maine
Paper towels, 1952

"Willie Wiredhand"
National Rural Electric Cooperative
Washington, D.C.
Electric utilities, 1953

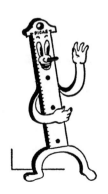
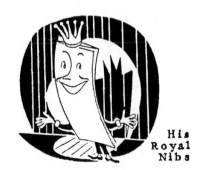
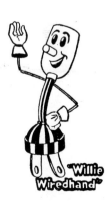

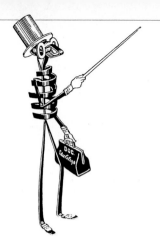
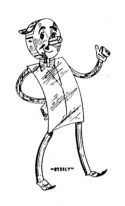
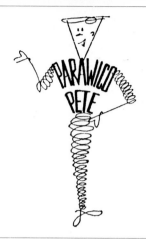

"Doc Steelstrap"
Acme Steel Company
Chicago, Illinois
Steel products, c. 1937

"Steely"
Madison Steel Company
Skokie, Illinois
Steel products, 1955

"Parawico Pete"
Paramount Wire Company
Brooklyn, New York
Metal wire, 1963

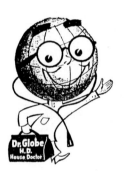

"Dr. Globe"
Globe Roofing Products Company
Whiting, Indiana
Construction materials, 1951

"Realy State"
Realy State, Inc.
South Miami, Florida
Real estate advertising
services, 1963

"Handy"
Bouncy Mfg. Company
Woodward, Oklahoma
Fishing line sinkers, 1955

"The RCA Service Man"
RCA Industrial Music Service
Camden, New Jersey
Music services, c. 1947

Blooper Enterprises
Miami, Florida
Phonograph records, 1953

"2-Way Mike"
Communications, Inc.
Rapid City, South Dakota
Communications equipment, 1964

"Djinelec"
Nord-Lumière
Paris, France
Electric utility, 1929

"Dudley Electric"
**Co-Operative Wholesale
Society, Ltd.**
Dudley, England
Electric machinery, 1939

"Mighty Midget"
Sperman Metal Specialties
Brooklyn, New York
Electric equipment, 1945

LE BON GENIE
DE L'ELECTRICITE

"Conrad the Control"
Dixie Controller, Inc.
North Birmingham, Alabama
Electric control panels, 1955

"Mr. Wirewell"
Electrical Contractors Assn.
Milwaukee, Wisconsin
Electrical contracting
services, 1962

"Danny Thunderbolt"
Plumbmaster
Concord Township, Pennsylvania
Power operated tools, 1955

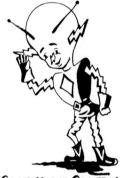

CONRAD THE CONTROL

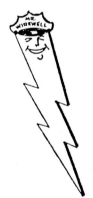

DANNY THUNDERBOLT

"Penny Therm"
The Bastian-Blessing Company
Chicago, Illinois
Public utility publicity, 1956

"Bud Butane"
**National Butane Company
of Alabama**
Mobile, Alabama
Liquified petroleum gas, 1958

"Quicky Carolane"
Carolina Butane Gas Company
Columbia, South Carolina
Liquified petroleum gas, 1956

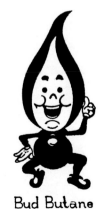

Bud Butane

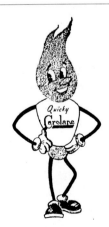

"Awawa"
**American Water Works
Association**
New York, New York
Water conservation, 1952

Panogen, Inc.
Ringwood, Illinois
Insecticide, 1954

"Little Oil Drop"
Humble Oil & Refining Company
Houston, Texas
Refined petroleum, 1958

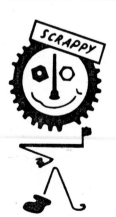

"Little Bill"
Commonwealth Edison Company
Chicago, Illinois
Public utility services, 1955

"Scrappy"
American Iron & Supply
Minneapolis, Minnesota
Metal recycling services, 1956

"Twisty"
Phillips Petroleum Company
Bartlesville, Oklahoma
Rubber masterbatch, 1956

"Charlie"
Charles Vending Company
Cleveland, Ohio
Vending machine service, 1956

"Miss Fluffy Rice"
**Rice Council
for Market Development**
Houston, Texas
Rice industry promotion, 1959

"Mike Microbe"
Union Tank Car Company
Chicago, Illinois
Sewage treatment
equipment, 1961

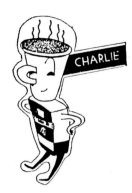

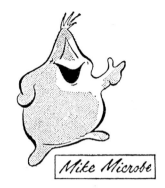

"Red Scissors"
Premium Associates, Inc.
Newark, New Jersey
Coupon promotions, 1959

Aceros Alfa Monterrey S.A.
Monterrey, Mexico
Steel pipe, 1962

"Mike Rite"
The Rogers Mfg. Company
Akron, Ohio
Pulleys, 1962

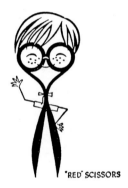

"KC"
Korody-Colyer Corporation
Wilmington, California
Industrial engine parts, 1962

"Charkey"
Georgia-Pacific Corporation
Portland, Oregon
Charcoal briquets, 1963

"Benchley"
Systems Corporation of America
Lakewood, Colorado
Lumber, 1968

"Sally Sunflower"
The Lewis Grocer Company
Indianola, Mississippi
Packed foods, 1967

"Sir Vac"
Sir Vac Incorporated
Orlando, Florida
Vacuum cleaners, 1969

"Chilly Billy"
Phillips Ice Service
Bowling Green, Kentucky
Manufactured ice, 1970

Sidney Smilo, Inc.
Los Angeles, California
Used machinery and tools, 1969

"RV"
Arvey Corporation
Chicago, Illinois
Business supply services, 1971

"The Big Green Cleaning Machine"
Green Valley Village, Inc.
Birmingham, Alabama
Automobile filling station, 1972

"Packy"
R.L. Hartley Corporation
Indianapolis, Indiana
Foam particles for packing, 1973

WWP, Inc.
Irvine, California
Water filtration apparatus, 1977

"Ricki the Rambunctious Raindrop"
Municipal Water District
Tustin, California
Water conservation, 1974

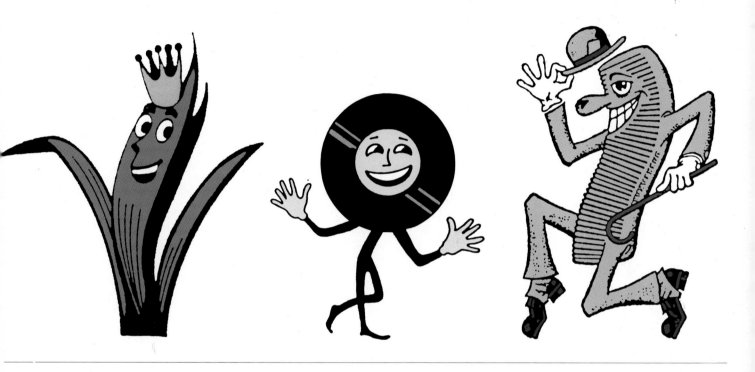

Lawn King, Incorporated
Fairfield, New Jersey
Lawn seed and fertilizer, 1970

Baly Records
North Hollywood, California
Records, 1972

Cunningham Comb Company
Newaygo, Michigan
Combs, 1980

Kellogg Company
Battle Creek, Michigan
Pastry, 1971

"Willy Whistle"
Department of Transportation
Washington, D.C.
Education in pedestrian
safety, 1976

**Kansas City Royals
Baseball Corp.**
Kansas City, Missouri
Baseball team newsletter, 1978

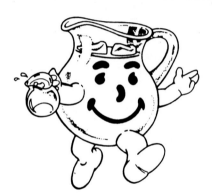

Foremost Sales Promotions
Chicago, Illinois
Alcoholic beverages, 1971

"The Kool-Aid Pitcher"
General Foods Corporation
White Plains, New York
Powdered soft drink, 1978

"U-Can"
Universal Can, Inc.
Roseville, Minnesota
Metal can recycling, 1980

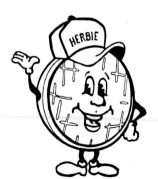

Carousel Industries
Morton Grove, Illinois
Coin operated machines, 1982

The Kroger Company
Cincinnati, Ohio
Photo finishing services, 1982

"Herbie"
Head Lites Corporation
St. Paul, Minnesota
Safety kits, 1985

"Carbonated Cleaner"
Harris Research, Inc.
Sacramento, California
Carpet cleaning compounds, 1977

"The Masked Mechanic"
Techfund, Inc.
Spring Valley, New York
Sports car information, 1980

Gremillion & Pou, Inc.
Shreveport, Louisiana
Bottled drinking water, 1987

Jalmarson International
Uppsala, Sweden
Metal hose clips, 1982

"The Talking House"
Realty Electronics
Fond du Lac, Wisconsin
Electronic real estate sales, 1983

"Cyclone Cider"
Happy Health Products, Inc.
Santa Barbara, California
Nutritional supplement, 1982

"The Talking House"

Snappy Taste & Results!

Lorin F. Berland
Dallas, Texas
Dental services, 1983

Mufco Industries
Elyria, Ohio
Muffler repair kits, 1982

"Mac Tonight"
McDonald's Corporation
Oak Brook, Illinois
Restaurant services, 1986

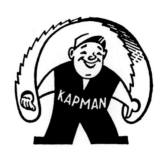

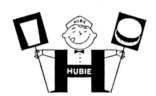
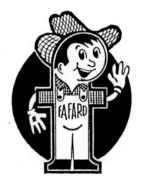
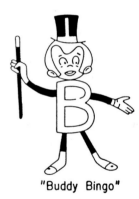

"Buddy Bingo"

"Roma Wine Man"
Roma Wine Company
Fresno, California
Wines, 1943

"Q1"
Essex Chemical Corporation
Clifton, New Jersey
Sodium Hexametaphosphate, 1953

"Kapman"
Kapman Aktiebolag
Veddige, Sweden
Handtools, 1963

"Handyman"
The Handyman of California
La Mesa, California
Retail hardware stores, 1969

"White Tower Boy"
White Tower Management Corp.
Stamford, Connecticut
Food and beverages, 1946

"Hubie"
Thomas Carvel
Yonkers, New York
Soft drinks, 1960

"Fafard"
Conrad Fafard, Inc.
Agawam, Massachusetts
Peat moss, 1964

"Buddy Bingo"
Capital Novelty Company
Philadelphia, Pennsylvania
Bingo game equipment, 1975

"Mr. Busy Dollar"
First Federal Savings & Loan Association of Watertown
Watertown, South Dakota
Personal loan services, 1957

"Reddy Cash"
Acceptance Finance Company
St. Louis, Missouri
Personal loan services, 1952

"Speedy Cash"
Gulfco Investment Group
Marksville, Louisiana
Personal loan services, 1961

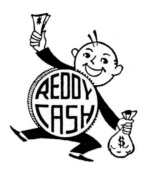

Mr. Busy Dollar

The Budget Plan, Inc.
Huntingdon, Pennsylvania
Personal loan services, 1963

Unity Savings Association
Chicago, Illinois
Banking services, 1974

"Hard Working Dollar"
First Federal Savings & Loan Association
Rochester, New York
Savings & loan services, 1975

The Harbor Sales Company
Baltimore, Maryland
Plywood, 1948

"Perm-A-Lator"
Flex-O-Lators, Inc.
Carthage, Missouri
Spring-wire pads, 1949

"The Blind Man"
Venetian Blind Mfg. Company
Chattanooga, Tennessee
Venetian blinds, 1956

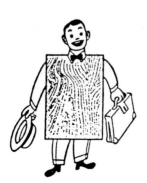

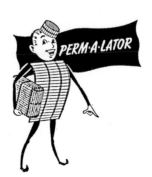

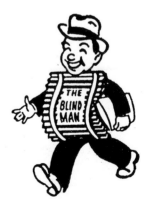

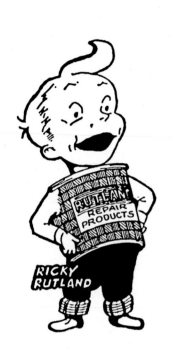

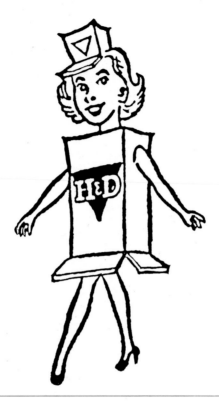

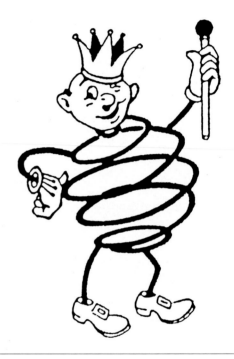

Cora Gated

"Ricky Rutland"
Rutland Fire Clay Company
Rutland, Vermont
Paints and stains, 1966

"Cora Gated"
The Hinde & Dauch
Paper Company
Sandusky, Ohio
Paperboard boxes, 1953

"King Koil"
The United States
Bedding Company
St. Paul, Minnesota
Mattresses & box springs, 1942

United Fibre Company
New York, New York
Rope and cordage, 1925

"General Paint"
General Paint Corporation
San Francisco, California
Paints, 1934

"Andy Sponge"
**American Sponge & Chamois
Company**
New York, New York
Sponges, 1934

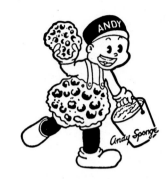

"Johnny Gear"
Diefendorf Gear Corporation
Syracuse, New York
Gears, c. 1947

"Chore-Boy"
Golay & Company
Cambridge City, Indiana
Pipeline milking systems, 1947

Priester Pecan Company
Fort Deposit, Alabama
Shelled pecans, 1954

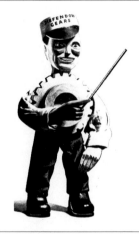

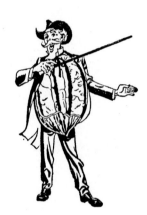

"Chief Seneca"
The Seneca Wire & Mfg. Company
Fostoria, Ohio
Wire, 1954

"Dusty Maid"
Vacuum Cleaner Bags, Inc.
Brooklyn, New York
Vacuum cleaner bags, 1960

"Carbie Carbcut"
Carball Industries
Eugene, Oregon
Chain grinders, 1963

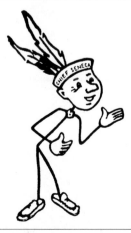
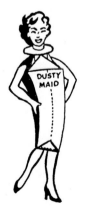
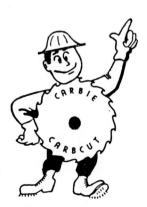

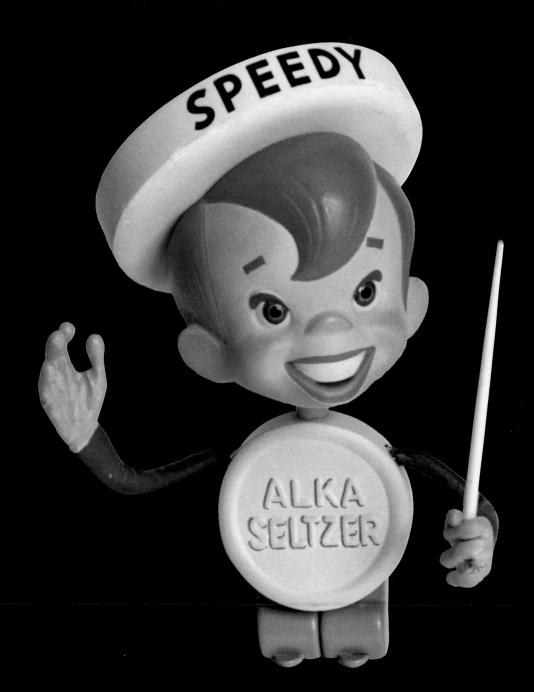

Speedy Alka-Seltzer

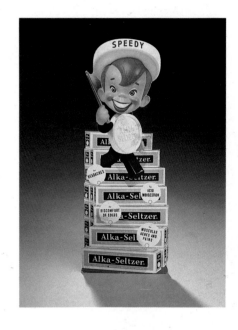

Speedy Alka-Seltzer was born in 1951 when A.G. Wade, head of Wade Advertising in Chicago, conceived the idea for a childlike spokesman for the effervescent analgesic tablets produced by Miles Laboratories. Robert Watkins was hired to sketch a baby-faced character with red hair and a tablet-shaped hat. Miles' sales manager renamed the character, who was originally labeled "Sparky," after that year's promotional theme, "Speedy Relief." Watkins' artwork was rushed into print in trade journals and women's magazines in early 1952.

The original Speedy Alka-Seltzer working model was six inches tall and was sculpted by Duke Russell. It soon became so famous that it was insured for $100,000 and stored in the vault of a Beverly Hills bank. Through the technique of stop-motion animation, Speedy appeared in over 200 television commercials from 1954 to 1964. He went bowling, talked on the telephone, sang and danced...and in 1961 even blasted off in a rocket to the moon.

The voice of Speedy was provided by Dick Beals, who was one of 400 individuals to audition for the job. The four foot, six inch Beals had an exclusive contract to supply the memorable vocal talent for all Alka-Seltzer commercials.

In addition to advertising, Speedy has been used in numerous point-of-purchase displays, most notably as a mannekin that played jingles for shoppers in the late 1950s. A vinyl Speedy promotional doll appeared in limited edition in 1955 and has since become a collector's item.

When the Alka-Seltzer account was switched from Chicago to New York in 1964, Speedy was given early retirement and replaced by a new marketing campaign. But for a generation of Americans who grew up with television in the 1950s, Speedy Alka-Seltzer and his famous jingle will be fondly remembered:

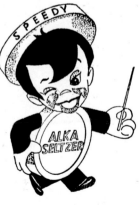

> Down, down, down the stomach through,
> Round, round, round the system too,
> With Alka-Seltzer you're sure to say,
> Relief is just a swallow away.

A *Speedy Alka-Seltzer* vinyl doll and point-of-purchase store display.

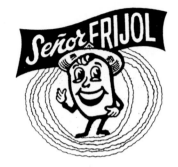

"Mr. Don"
Valley Growers Packing Company
Turner, Kansas
Fresh vegetables, 1955

"Mr. Hollymatic"
Hollymatic Corporation
Chicago, Illinois
Patty papers for meat, 1953

"Señor Frijol"
Western Farmers Association
Seattle, Washington
Beans, 1958

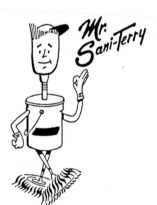
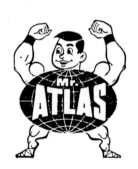

"Mr. 2-Ply"
Horace Small Mfg. Company
Nashville, Tennessee
Blended polyester goods, 1959

"Mr. Sani-Terry"
A. Cohen
Washington, D.C.
Floor cleaners, 1962

"Mr. Atlas"
Atlas Lift Truck Rentals & Sales
Schiller Park, Illinois
Machinery, 1963

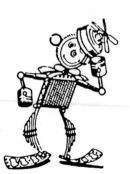
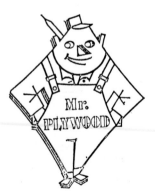
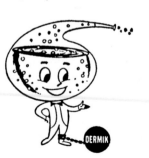

"Mr. Complete"
Complete Auto Parts
Gainesville, Georgia
Auto parts, 1965

"Mr. Plywood"
Howard Robinson
Vancouver, Washington
Plywood, 1964

"Mr. Benzie"
Demik Pharmacal Company
Syosset, New York
Acne lotions, 1965

"Mr. Suds"
One One Three, Inc.
Council Bluffs, Iowa
Gasoline, 1970

"Mr. Swifty"
Avenue Equipment Corporation
Hinsdale, Illinois
Grocery store services, 1969

"Mr. Gas"
Larry L. Shed
Hobbs, New Mexico
Gasoline, 1970

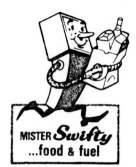

"Mr. Fresh"
International Paper Company
New York, New York
Paperboard boxes, 1967

"Mr. Yuk"
Children's Hospital of Pittsburgh
Pittsburgh, Pennsylvania
Poison prevention
information, 1972

"Mr. Fresh"
G.P. Gundlach & Company
Fairfax, Ohio
Laundry detergent, 1974

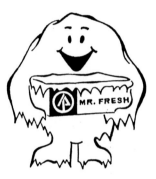

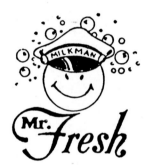

"Mr. Insecto Cutor"
Insect-O-Cutor, Inc.
Stone Mountain, Georgia
Flying insect exterminator, 1971

"Mr. Ice"
Mister Ice Company
Loveland, Colorado
Ice making machines, 1973

"Mr. Lube"
Mr. Lube Lubrication Ltd.
Edmonton, Canada
Automobile repair, 1978

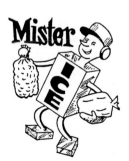

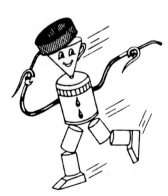

"Mr. Orange"
Pure Gold
Redlands, California
Fresh oranges, 1955

"Mr. Donut"
Mister Donut of America, Inc.
Brookline, Massachusetts
Snack bar services, 1955

"Mr. Apricot"
Wileman Bros. & Elliott, Inc.
Cutler, California
Fresh apricots, 1962

"Mr. Salty"
National Biscuit Company
New York, New York
Pretzels, 1964

"Mr. Potato"
Spudco, Inc.
Edison, California
Potatoes, 1962

"Mr. Dell"
Dell's Potato Company
Kansas City, Missouri
Processed potatoes, 1973

 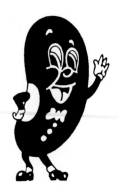 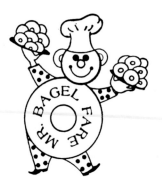

"Mr. Lemon"
Mister Lemon, Inc.
South Attleboro, Massachusetts
Restaurant services, 1972

"Mr. Bean"
Sunset Foods, Inc.
Los Angeles, California
Prepared bean dips, 1972

"Mr. Bagel Fare"
Bagel Fare Systems, Inc.
North Miami Beach, Florida
Sandwiches, 1973

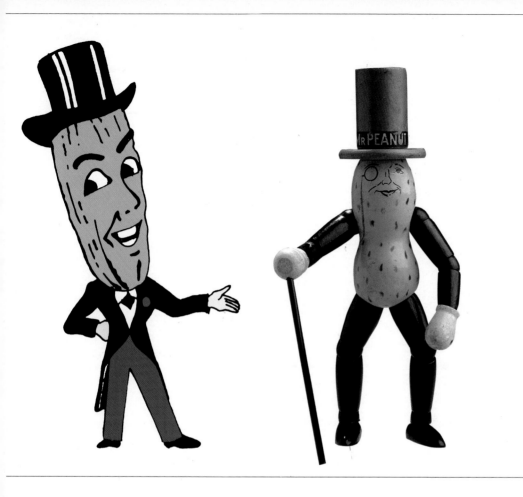

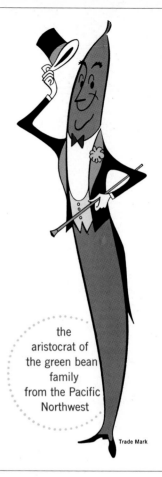

the
aristocrat of
the green bean
family
from the Pacific
Northwest

Trade Mark

"Mr. Pickle"
Atkins Pickle Company
Atkins, Arkansas
Pickles, 1968

"Mr. Peanut"
Planter's Nut & Chocolate Co.
Suffolk, Virginia
Peanuts, 1918

"Mr. Blue Lake"
**Associated Blue Lake Green
Bean Canners, Inc.**
Portland, Oregon
Canned green beans, 1953

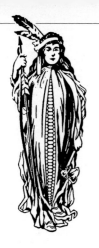

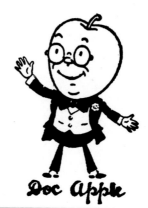

"Argo Starch Girl"
Corn Products Refining Company
New York, New York
Cornstarch, 1913

Central California Berry Growers Association
San Jose, California
Fresh berries, 1922

"Doc Apple"
Pacific Northwest Fruits, Inc.
Yakima, Washington
Apples, 1937

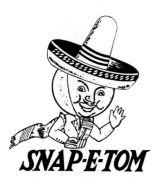

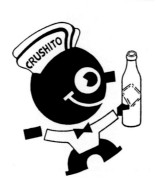

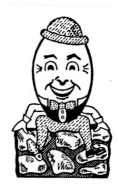

"Snap-E-Tom"
E.C. Ortega Company
Los Angeles, California
Soft drink, 1940

"Crushito"
Orange-Crush Company
Chicago, Illinois
Soft drinks, 1946

"Humpty Dumpty"
Humpty Dumpty Potato Chip Co.
Scarborough, Maine
Potato chips, 1947

Paul F. Beich Company
Bloomington, Illinois
Candy, 1947

American Cranberry Exchange
New York, New York
Fresh cranberries, 1948

Plains Seed & Delinting Company
Lubbock, Texas
Cotton seed insecticides, 1950

"The Smiling Oyster"
Olympia Oyster Company
Shelton, Washington
Fresh oysters, 1952

"Pepito Pimento"
Ventura Farms Frozen Foods, Inc.
Oxnard, California
Diced frozen pimentos, 1954

Snack Foods, Inc.
Jeffersonville, Indiana
Corn chips, 1958

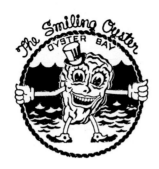
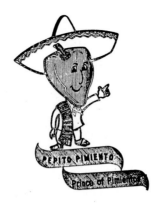

Albert Miller & Company
Chicago, Illinois
Potatoes, 1938

"Michigan Chef's Choice"
Michigan Potato Industry Comm.
Lansing, Michigan
Certified potatoes, 1962

"Top Tater"
Central Sands Produce, Inc.
Bancroft, Wisconsin
Potatoes, 1963

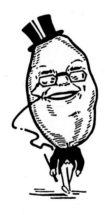
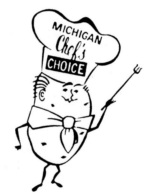
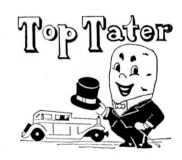

Central Soya Company, Inc.
Fort Wayne, Indiana
Soybean products, 1962

"Mr. Pizza"
Mr. Pizza Enterprises
Raleigh, North Carolina
Pizza restaurant, 1967

Zaloom Brothers, Inc.
Secancus, New Jersey
Roasted nuts, 1963

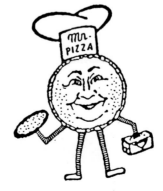

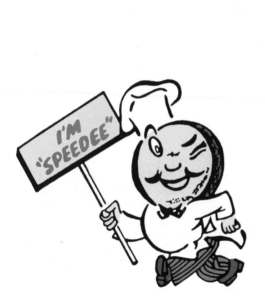

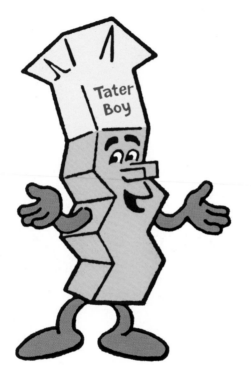

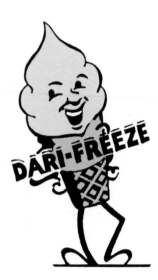

"Speedee"
McDonald's Corporation
Oak Brook, Illinois
Restaurant services, 1958

"Tater Boy"
Rogers Walla Walla, Inc.
Walla Walla, Washington
Frozen french fried potatoes, 1969

"Dari-Freeze"
Carvel Corporation
Yonkers, New York
Frozen custards and
ice cream, 1948

"Dunkie"
Dunkin' Donuts of America
Quincy, Massachusetts
Restaurant services, 1954

"Snow Chef"
Snow Chef, Inc.
St. Louis, Missouri
Frozen fruits and vegetables, 1963

"Tastee"
Tastee Freeze International
Chicago, Illinois
Restaurant services, 1961

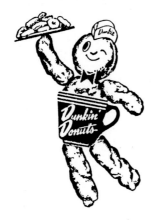

"Little Foster"
Fosters Freeze, Inc.
Santa Barbara, California
Restaurant services, 1965

"Mr. Softee"
Mister Softee, Inc.
Runnemede, New Jersey
Mobile ice cream trucks, c. 1965

"Whippy"
Orange Whip Corporation
Los Angeles, California
Fruit drinks, 1972

"Saporino"
Augusto Badoglio
Milan, Italy
Garlic and onion powders, 1970

"Poppin' Fresh"
The Pillsbury Company
Minneapolis, Minnesota
Frozen pastries, 1971

"Dough Boys"
The Dough Boys, Inc.
West Mifflin, Pennsylvania
Restaurant services, 1980

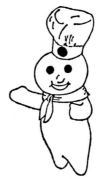

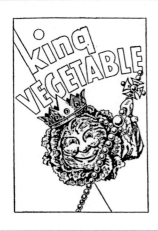

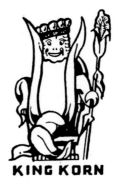

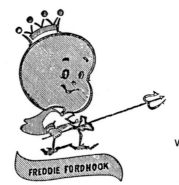

"King Vegetable"
T. Fukuhara
Arroyo Grande, California
Vegetables, 1939

"King Korn"
Big Stone Canning Company
Ortonville, Minnesota
Canned vegetables, 1941

"Freddie Fordhook"
Ventura Farms Frozen Foods, Inc.
Oxnard, California
Frozen lima beans, 1947

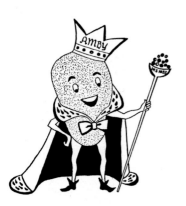

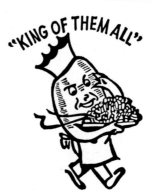

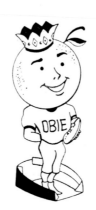

"Amby"
Ambrosia Chocolate Company
Milwaukee, Wisconsin
Chocolate flavorings, 1953

"King of Them All"
George J. Leggio
Rockford, Illinois
French fried potatoes, 1954

"Obie"
The Orange Bowl Committee
Miami, Florida
College football games, 1956

"King of Fruits"
**Hudson Valley Apple
Products, Inc.**
Milton, New York
Apples, 1970

"The Royal Bagel"
Simcha Corporation
Atlanta, Georgia
Bagels, 1975

"Jellybean Queen"
Jellybean Queen, Inc.
St. Paul, Minnesota
Jellybeans, 1980

"Lil' Pickle"
Lil' Pickle, Inc.
Costa Mesa, California
Restaurant services, 1968

North Carolina Yam Commission
Raleigh, North Carolina
Sweet potato promotion, 1967

"Farmer Goober"
Curtis Nuts, Inc.
South San Francisco, California
Processed peanuts, 1971

The Pillsbury Company
Minneapolis, Minnesota
Watermelon-flavored
soft drinks, 1974

"Mr. Gourd"
Mr. Gourd of California, Inc.
San Diego, California
Planters made from gourds, 1975

**Lucam Import and
Export Company**
Miami, Florida
Coffee, 1975

"Humpty Dumpty"
Walgreen Arizona Drug Company
Deerfield, Illinois
Restaurant services, 1976

Omelet Shoppe, Inc.
Birmingham, Alabama
Restaurant services, 1977

Wisconsin's Best Relish Co., Inc.
Twin Lakes, Wisconsin
Pickles and relishes, 1977

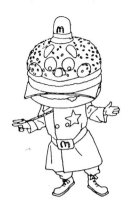

"Kernal Korn"
Kernal Korn, Inc.
Oklahoma City, Oklahoma
Popcorn, 1976

"Big Mac"
McDonald's Corporation
Oak Brook, Illinois
Restaurant services, 1976

"Fluffy"
Mom 'N' Pop's, Inc.
Claremont, North Carolina
Meat filled biscuits, 1981

THE BURGER BEATERS

"The Burger Beaters"
Taco Bravo International, Inc.
Fort Lauderdale, Florida
Tacos, 1979

"Goncho"
Mexicone, Ltd.
San Diego, California
Corn tortilla fillings, 1981

Pure Gold, Inc.
Redlands, California
Citrus fruits, 1980

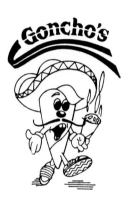

Eastern Onion, Inc.
Las Vegas, Nevada
Singing telegrams, 1981

Peaches Records & Tapes, Inc.
Los Angeles, California
Retail tape and record sales, 1980

**The Arkansas Rice Growers
Cooperative**
Stuttgart, Arkansas
Rice, 1980

"Raisin Wives of California"
Raisin Wives of California, Inc.
Fresno, California
Raisins, 1973

"California Raisin"
California Raisin Advisory Board
Fresno, California
Raisin promotion and
marketing, 1988

"California Raisin"
California Raisin Advisory Board
Fresno, California
Raisin promotion and
marketing, 1986

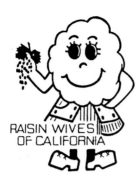

Wheat Industry Council
Washington, D.C.
Wheat product information, 1985

"Snappy"
Snappy Tomato Pizza, Inc.
Cincinnati, Ohio
Pizza restaurants, 1985

"Sushi Maid"
Oseka Machine Company
Elyria, Ohio
Utensil for making sushi, 1985

Cookies Cook'n, Inc.
Woburn, Massachusetts
Restaurant services, 1981

"Buster Billy"
Apopka Dairy Queen
Apopka, Florida
Restaurant services, 1985

"Hal O. Peno"
Hal O. Peno's, Inc.
Phoenix, Arizona
Restaurant services, 1989

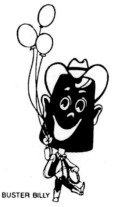

BUSTER BILLY

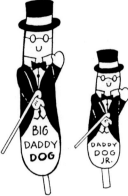

Fletcher's Industries, Inc.
Lewisville, Texas
Snack bar services, 1942

"Tater-dog"
Lite-Ron Industries, Inc.
Orange, California
Wrapped hot dogs, 1953

*"Big Daddy Dog
and Daddy Dog Junior"*
Kiddie-Land
Memphis, Tennessee
Corn dog mix, 1969

Beef Villa, Inc.
West Dundee, Illinois
Restaurant services, 1970

"Frankie"
Superior Brand Meats, Inc.
Prepared meat products, 1970

Ambassador Sausage Corporation
Minneapolis, Minnesota
Sausages, 1973

Nathan's Famous, Inc.
New York, New York
Restaurant services, 1977

"Mr. Hotdog"
H & H Appliances, Inc.
Whittier, California
Electric hot dog cookers, 1977

Buccaneer Enterprises, Inc.
Riverview, Florida
Hot dogs, 1977

Doughtie's Foods, Inc.
Portsmouth, Virginia
Meat frankfurters, 1978

Ray's Grocery
Opelousas, Louisiana
Meats and sausages, 1981

"Mr. Big Furter"
Mountain Enterprises, Inc.
Parsippany, New Jersey
Technical aid in the establishment
of frankfurter vending stands, 1981

Jaffe-Ben Shea, Inc.
Santa Barbara, California
Hot dogs and buns, 1981

"Weenies"
Kiss Communications, Inc.
Edgewater, New Jersey
Books and T-shirts, 1983

"W.C. Frank"
Robert R. Blank
Omaha, Nebraska
Restaurant services, 1982

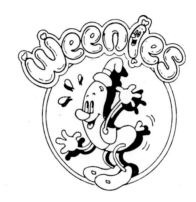

"Funny Frank"
Funny Frank's, Inc.
Dallas, Texas
Fast food vending services, 1984

"Captain O"
Ohds, Inc.
Pittsburgh, Pennsylvania
Restaurant services, 1987

"Pacific Coast Hot Dog"
Leroy Clubb
San Diego, California
Hot dogs, 1988

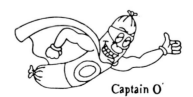

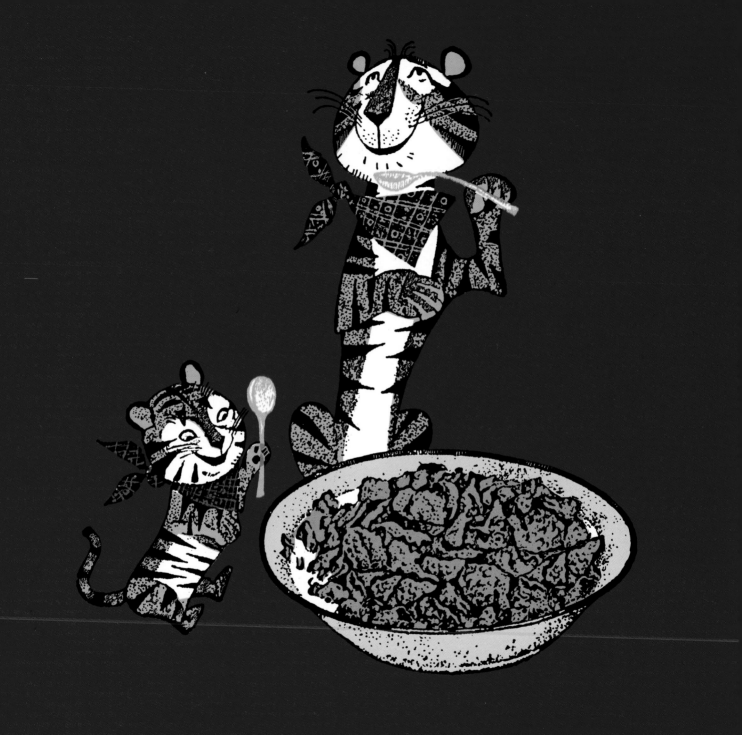

Animal Character Marks

Animals have served proudly as trade characters for many years. College teams have always recognized their value as sports mascots. The unique qualities of animals make them ideal for certain businesses; personified, they become mascots for their corporate sponsors.

Willie and Millie the penguins have sold Kool cigarettes for the Brown & Williamson Tobacco Company since the 1940s. The pair of puffing penguins, representing both sexes, of course, was designed to project "coolness" as well as to play off the product's name. Loveable *Granny Goose,* smartly dressed in apron and bonnet, has advertised potato chips for Barr Foods since 1946. Another bird, *Fresh-Up Freddie,* was mascot for the 7-Up Bottling Company in the 1950s.

Easily animated for starring roles in television commercials, these animals and others made terrific trade characters. Unlike their human counterparts, as cartoon characters they could be depicted in a variety of impossible situations. For years *Charlie the Tuna* promoted Star-Kist tuna in animated form as the bad fish who finds it impossible to be caught. During the 1970s the put-down line, "Sorry Charlie," became part of our language.

Perhaps the most bizarre of all animal trademarks was *Chicken Boy,* a half man/half chicken who perched atop the Chicken Boy restaurant in Los Angeles. When the restaurant closed in 1984, Chicken Boy was rescued by some fans who resurrected him as the central figure of a cult following. No longer just a restaurant trademark, he was perceived as a goofy symbol for Los Angeles and all of the people who move to the city but feel as if they don't quite belong. Under the auspices of Future Studio, a catalog of Chicken Boy merchandise is offered for sale; he lives on in the hearts of many as the Statue of Liberty of Los Angeles.

These *Willie and Millie* salt and pepper shakers graced the kitchen tables of many American homes during an era when cigarette smoking was still a socially acceptable thing to do.

Tony the Tiger and *Tony, Jr.* have sold Kellogg's Frosted Flakes since 1953. Also dating from the 1950s, this *Fresh-Up Freddie* vinyl doll was a promotional toy for the 7-Up Bottling Company.

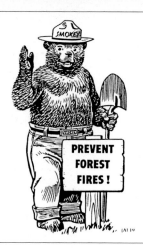

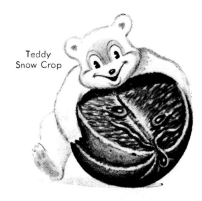

Teddy
Snow Crop

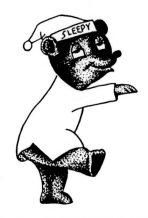

PREVENT
FOREST
FIRES !

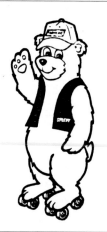

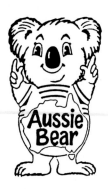

Aussie
Bear

"Bear"
**Bear Automotive Service
Equipment Company**
Milwaukee, Wisconsin
Wheel alignment equipment, 1931

"Smokey the Bear"
U.S. Department of Forestry
Washington, D.C.
Forest fire prevention, 1949

"Teddy Snow Crop"
Clinton Foods, Inc.
New York, New York
Frozen orange juice, 1953

"Sleepy Bear"
Travelodge Corporation
El Cajon, California
Motels, 1954

"Hamm's Bear"
Hamm Brewing Company
Milwaukee, Wisconsin
Beer, c. 1955

"Rheingold Bear"
Rheingold Breweries, Inc.
Brooklyn, New York
Beer, 1971

"A & W Bear"
A & W International, Inc.
Santa Monica, California
Soft drinks, 1974

"Sevylor Bear"
Sevylor
Paris, France
Life jackets, 1977

"Yogi Bear"
Columbia Pictures Industries, Inc.
New York, New York
Recreational campgrounds, 1976

"Speedy"
Associated Bearings Company
Kansas City, Missouri
Bearings, 1981

"Snuggles"
Lever Brothers Company
New York, New York
Fabric softener, 1982

"Aussie Bear"
MacRobertson Proprietary Ltd.
Victor, Australia
Cocoa and chocolate, 1983

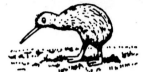

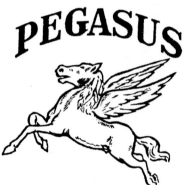

Arnott's Biscuit Pty. Ltd.
Sydney, Australia
Biscuits and cakes, 1907

Standard Oil Company
New York, New York
Petroleum products, 1911

Kiwi Polish Company, Ltd.
Victoria, Australia
Shoe and boot polish, 1908

R.J. Reynolds Tobacco Company
Winston-Salem, North Carolina
Cigarettes, 1913

University of Miami
Coral Gables, Florida
Athletic events, 1926

Creighton University
Omaha, Nebraska
Athletic events, 1925

University of Miami
Coral Gables, Florida
Athletic events, 1926

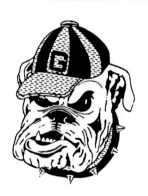
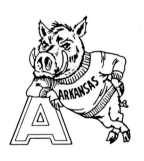

University of North Carolina
Chapel Hill, North Carolina
Athletic events, 1945

University of Georgia
Athens, Georgia
Football games, 1958

The University of Arkansas
Little Rock, Arkansas
Athletic events, 1958

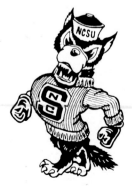
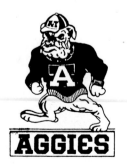
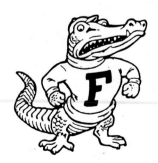

AGGIES

North Carolina State University
Raleigh, North Carolina
Athletic events, 1964

A & T University Foundation
Greensboro, North Carolina
Fund raising services, 1971

University of Florida
Gainesville, Florida
Athletic events, 1980

"Elsie the Cow"
The Borden Company
New York, New York
Dairy Products, 1945

"Elmer the Cow"
The Borden Company
New York, New York
Elmer's glue, 1953

"Good Steer"
Good Steer Drive-In, Inc.
Lake Grove, New York
Restaurant services, 1957

"Bully Boy"
Bully Boy Company
Bakersfield, California
Fertilizer, 1959

"Mr. Steak"
Mr. Steak, Inc.
Denver, Colorado
Restaurant services, 1962

Nemeth's el Tejon Restaurant
Colorado Springs, Colorado
Restaurant services, 1962

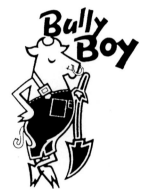 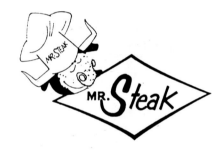

P & D Mfg. Company
Plainfield, Illinois
Feed handling equipment, 1966

"Sammy Steer"
American Beef Packers, Inc.
Omaha, Nebraska
Beef products, 1971

Sirloin Stockade, Inc.
Oklahoma City, Oklahoma
Restaurant services, 1973

Standard Brands, Inc.
New York, New York
Kibbled dog food, 1948

Dog n Suds, Inc.
Champaign, Illinois
Restaurant services, 1955

Alabama Flour Mills
Omaha, Nebraska
Dog meal, 1954

Mack Trucks, Inc.
Allentown, Pennsylvania
Truck maintenance and
repair, 1971

Dog n Suds, Inc.
Camden, New Jersey
Restaurant services, 1973

Snyder-Darien Corporation
Corfu, New York
Recreational campsites, 1973

"Dot"
Dot Pasteup Supply Company
Omaha, Nebraska
Graphic art supplies, 1973

St. Bernard Coal Company
Louisville, Kentucky
Coal, 1978

"Sherlock Bones"
John Keane
Oakland, California
Detective agency for locating
lost animals, 1979

Campbell Soup Company
Camden, New Jersey
Restaurant services, 1981

"McGruff"
The Advertising Council, Inc.
New York, New York
Advertising campaigns promoting
crime prevention, 1979

Max Meyer S.p.A.
Milano, Italy
Paints and varnishes, 1980

"Charlotte"
Charlotte Sports Promotion
Charlotte, North Carolina
Cheerleading services, 1980

"Smart Alex"
Xerox Corporation
Stamford, Connecticut
Book club services, 1980

"Lucky Dog"
Ralston Purina Company
St. Louis, Missouri
Pet food, 1982

"The Booze Hound"
Allan A. Buergin
Eatontown, New Jersey
Ceramic cups and mugs, 1979

"Spuds Mackenzie"
Anheuser-Busch, Inc.
St. Louis, Missouri
Light beer, 1986

"Ike"
Ralston Purina Company
St. Louis, Missouri
Dog food, 1988

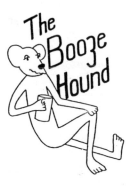

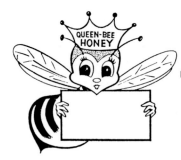

Tropical Blossom Honey
Edgewater, Florida
Honey, 1951

Bee Wholesale Drug
Van Nuys, California
Prescription pharmaceuticals, 1962

"Queen-Bee"
Nickerson Farms
Eldon, Missouri
Honey, 1963

Devine Fashions, Inc.
Bensenville, Illinois
Ladies' clothing, 1964

"Shutter Bug"
Photo Bug, Inc.
Cincinnati, Ohio
Film processing services, 1969

Stinger Sam
Springfield, Missouri
Retail automotive parts, 1966

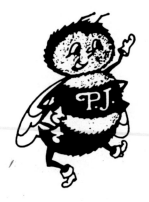

Lee B. Stern
Chicago, Illinois
Professional soccer games, 1975

"The Sound Bug"
Trans Continental Engineering
Sumner, Washington
Repair kit and manual, 1977

"P.J."
Bittner Apiaries, Inc.
Evansville, Indiana
Honey, 1978

Tyson Foods, Inc.
Springdale, Arkansas
Processed chicken, 1975

Natural Products, Inc.
Culver City, California
Frozen confections, 1977

"Honey Bee"
General Mills, Inc.
Minneapolis, Minnesota
Breakfast cereal, 1980

Barnes Enterprises, Inc.
Syracuse, New York
Bingo game forms, 1979

"Jollibee"
Jollibee Foods Corporation
Quezon City Metro, Philippines
Hamburgers, 1983

"Freeze Bee"
Slush Puppie Corporation
Cincinnati, Ohio
Frozen ice milk dispensers, 1981

"The Birthday Bee"
Birthday Bee Company
North Providence, Rhode Island
Party services, 1983

"Stinger"
Chevron, Inc.
Mercer, Pennsylvania
Wrecker trucks, 1986

"Wonder Bee"
Wonder Bee, Inc.
Los Angeles, California
Royal jelly and bee pollen, 1988

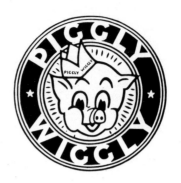

"Hamlet"
**The Sugardale Provision
Company**
Canton, Ohio
Cooked weiners and ham, 1941

Oldham's Farm Sausage Co.
Lee's Summit, Missouri
Sausage, 1946

"Piggly Wiggly"
Piggly Wiggly Corporation
Jacksonville, Florida
Grocery stores, 1951

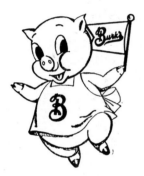
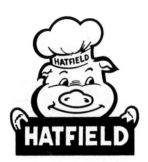
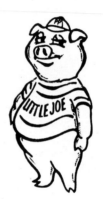

"Burk"
Louis Burk Company
Philadelphia, Pennsylvania
Sausages and canned meat, 1956

Hatfield Packing Company
Hatfield, Pennsylvania
Meat products, 1956

"Little Joe"
Maurice's Piggy Park
West Columbia, South Carolina
Restaurant services, 1960

Pig 'N' Pancake, Inc.
Seaside, Oregon
Restaurant services, 1961

"Canteen"
Nelson Sales Company
Sioux City, Iowa
Animal feeder equipment, 1983

Pierce Packing Company
Billings, Montana
Sliced bacon, 1965

Evans Food Products Co.
Chicago, Illinois
Pork rinds, 1975

Detroit Rib Factory
San Diego, California
Restaurant services, 1977

"Picky Pigg"
Picky Pigg's Pork Pen
Reading, Pennsylvania
Restaurant services, 1979

"Horni Porni"
Structural Graphics, Inc.
Old Saybrook, Connecticut
Greeting cards, 1980

"Slim Piggums"
Gary Rosenthal & Donald Hall
Scarsdale, New York
Pork barbecue with sauce, 1982

**Chicago, Missouri & Western
Railway Company**
Chicago, Illinois
Transportation services, 1987

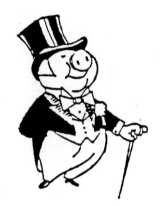

"Big Al"
Alberto R. Abrante
Miami, Florida
Pork rinds, 1988

Sermac Industries, Inc.
Altoona, Pennsylvania
Dust cloths, 1988

"Leisure Pig"
Leisure Pigs Products, Ltd.
Victoria, Canada
Clothing, 1989

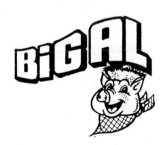

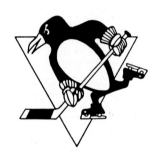

Little America Refining Company
Cheyenne, Wyoming
Gas station services, 1936

"Coldspot Penguin"
Sears, Roebuck and Company
Chicago, Illinois
Refrigerators, c. 1950

Penguin Point Franchise Systems
Warsaw, Indiana
Restaurant services, 1949

"Munsingwear Penguin"
Munsingwear, Inc.
Minneapolis, Minnesota
Apparel, 1969

Skating Rink Supply Company
Acmar, Alabama
Indoor roller skate rinks, 1952

Ray Travers
Watsonville, California
Apples, 1957

Susie-Q Restaurants
Birmingham, Michigan
Restaurant services, 1969

Pittsburgh Penguins
Pittsburgh, Pennsylvania
Hockey team, c. 1970

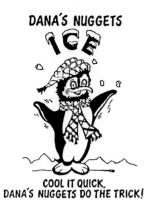

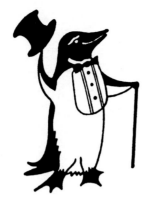

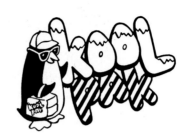

Dana Ice Company
San Luis Obispo, California
Ice, 1973

The Taubman Company
Hayward, California
Ice skating rinks, 1975

Tuxedo Time Formal Wear
Dorchester, Massachusetts
Formal wear, 1982

Maitre D Products, Inc.
Stanton, California
Non-alcoholic cocktail mixes, 1977

Kool Pak, Inc.
Naples, Florida
Insulated carrying bag, 1983

International Cooling Experts
Lansdale, Pennsylvania
Automotive cooling systems, 1981

Prodrill Oil Supply, Inc.
Houston, Texas
Frozen seafood, 1984

Aldoph Coors Company
Golden, Colorado
Citrus-flavored alcoholic
beverage, 1985

Marshall Smoked Fish Company
Brooklyn, New York
Smoked fish, 1948

De Met's, Inc.
Chicago, Illinois
Candy, 1948

Turtle Wax, Inc.
Chicago, Illinois
Chrome polish, 1955

L.M. Sandler & Sons, Inc.
Virginia Beach, Virginia
Packaged seafood, 1955

Kaiser Aluminum & Chemical Corp.
Oakland, California
Fertilizers for fish ponds, 1957

Nunemaker Fish Company
Nags Head, North Carolina
Retail fish sales, 1961

 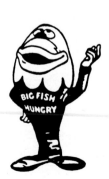

Moncton Broadcasting Ltd.
Moncton, Canada
Television broadcasting, 1969

Michigan Food Sales
Detroit, Michigan
Frozen seafoods, 1970

"Big Fish Hungry"
The Red Barn System, Inc.
Fort Lauderdale, Florida
Fish sandwiches, 1972

"Flip the Frog"
Patrick Anthony Powers
New York, New York
Animated films, 1931

"Charlie the Tuna"
Star-Kist Foods, Inc.
Terminal Island, California
Canned fish, 1977

"Goldie the Golden Seal"
Gold Seal Company
Bismarck, North Dakota
Glass wax, 1952

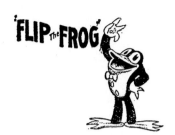

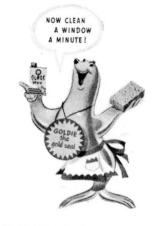

"Masonry Seal"
Masonry Seal Corporation
Vermillion, Ohio
Masonry waterproofing, 1969

"Water Seal"
E.A. Thompson Company, Inc.
San Francisco, California
Waterproofing preparations, 1951

"Security Seal"
Lily-Tulip, Inc.
Toledo, Ohio
Tamper indicative labels and
closures for containers, 1982

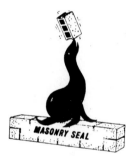

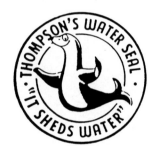

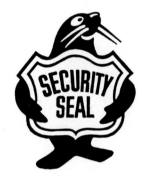

"Señor Froggy"
David R. Hooke
Spokane, Washington
Mexican restaurant services, 1979

"The Happy Crabber"
**Fid-O/McGrew Splicing
Tool Company**
Elverta, California
Marlinspikes for splicing twisted
fiber ropes, 1978

"Noisy Oyster"
Noisy Oyster Seafood Cafe
Myrtle Beach, South Carolina
Restaurant services, 1982

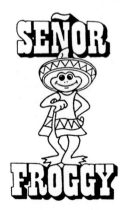

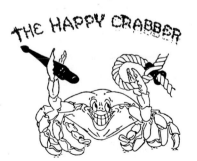

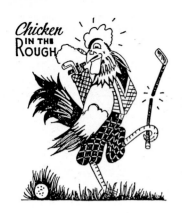

"Chicken in the Rough"
Beverly's Drive-In
Oklahoma City, Oklahoma
Chicken lunches, 1938

Host International, Inc.
Santa Monica, California
Fresh chicken, 1960

Colonial Chicken Systems, Inc.
South Miami, Florida
Restaurant services, 1969

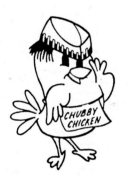

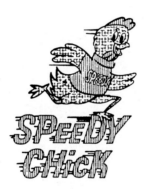

"Chubby Chicken"
A & W International, Inc.
Santa Monica, California
Fried chicken, 1965

"Speedy Chick"
Speedy Chick, Inc.
Chicago, Illinois
Fried chicken, 1966

"General Fry"
General Fry's Chicken and Pies
Pittsburgh, Pennsylvania
Restaurant services, 1969

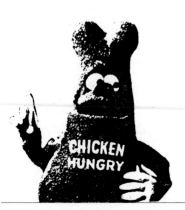

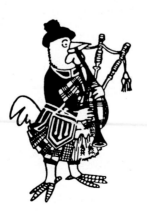

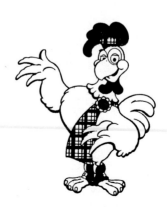

"Chicken Hungry"
The Red Barn System, Inc.
Fort Lauderdale, Florida
Fried chicken, 1971

General Poultry
Baldwin, Georgia
Fresh and frozen chicken, 1972

Scott's Restaurants Company, Ltd.
Miami, Florida
Restaurant services, 1978

Golden Drumstick, Inc.
Tulsa, Oklahoma
Restaurant services, 1979

"Chicken Boy"
Chicken Boy Restaurant
Los Angeles, California
Restaurant services, 1969

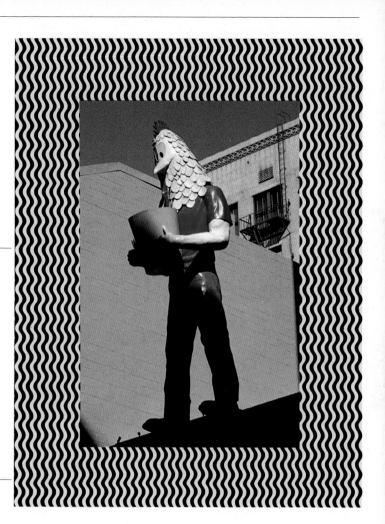

"The Incredible Kluk"
Brakebush Brothers, Inc.
Westfield, Wisconsin
Chicken distributorship, 1981

Kountry Folks Restaurants, Inc.
Simi Valley, California
Restaurant services, 1982

"Doctor Chicken"
Doctor Chicken, Inc.
Philadelphia, Pennsylvania
Restaurant services, 1982

"Jose Pepper"
Jose Pepper's, Inc.
Seattle, Washington
Restaurant services, 1984

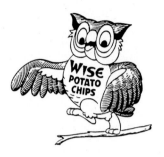

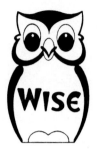

"Peppy"
Wise Potato Chip Company
Berwick, Pennsylvania
Potato chips, 1955

"Peppy"
Borden, Inc.
Columbus, Ohio
Potato chips, 1976

"Orval Right"
**United States Army Agency
for Aviation Safety**
Fort Rucker, Alabama
Aviation newsletter, 1972

"Newell"
The Nu•Wool Wise Old Owl

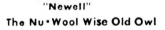

**Castleberry Instruments
& Avionics**
Austin, Texas
Aircraft instruments, 1960

"Newell"
Nu-Wool Insulation Co., Inc.
Hudsonville, Michigan
Cellulose fiber insulation, 1978

Elizabethtown Gas Company
Elizabeth, New Jersey
Public utility services, 1979

"Mr. Wize Buys"
Gerald R. Neva
Lincoln, Nebraska
Floor coverings, 1973

"Dr. Intermed"
Intermed-USA, Inc.
New York, New York
Provision of aid to people
in foreign lands, 1977

Red Owl Stores, Inc.
Hopkins, Minnesota
Sewing kits, 1978

"Webster"
Drake Bakeries, Inc.
Brooklyn, New York
Cakes and cookies, 1938

The Gillette Company
Boston, Massachusetts
Safety razors and blades, 1952

"Malco"
Malone Knitting Company
Springfield, Massachusetts
Children's underwear, 1957

"The Best Dressed Turkey in Town"
Bil-Mar Foods, Inc.
Zeeland, Michigan
Fresh dressed turkey, 1963

Crane Potato Chip Company
Springfield, Illinois
Potato chips, 1946

"Old Crow"
W.A. Gaines & Company
Grier's Creek, Kentucky
Whiskey, 1963

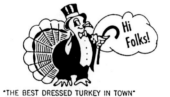

"Cuervo"
Jose Luis Saavedra
Maywood, California
Hot sauce, 1971

The Stork Club Restaurant, Inc.
New York, New York
Restaurant services, 1971

Vlasic Foods, Inc.
Lathrup Village, Michigan
Pickles and relishes, 1974

 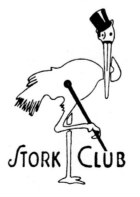

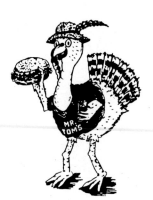

"Granny Goose"
Barr Foods, Inc.
Oakland, California
Potato chips, 1946

Dan's Sewer Service, Inc.
Middletown, New York
Septic tank cleaning, 1962

"The Problem Solver"
Professional Modular Surface, Ltd.
Hinsdale, Illinois
Rubber flooring, 1982

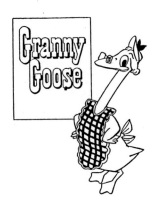

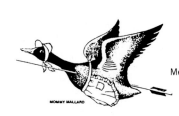

Gold Seal Rubber Company
Boston, Massachusetts
Sports bags, 1983

"Dex"
Dexter Shoe Company
Boston, Massachusetts
Men's and women's shoes, 1980

"Mommy Mallard"
Happy Parenting Institute
Philadelphia, Pennsylvania
Printed flyers dealing with
family relationships, 1982

"Pretty Boy"
Audubon Park Company
Akron, Ohio
Wild bird food, 1980

Duck Records Ltd.
London, England
Phonograph records and
tapes, 1983

"Mr. Tom"
Mr. Tom's Turkey Bar-B-Q, Inc.
Kingston, Pennsylvania
Restaurant services, 1984

"Mr. Horsepower"
Clay-Smith Engineering
Buena Park, California
Cam shafts, 1959

Kellogg Company
Battle Creek, Michigan
Breakfast cereal, 1964

"Speedy Rooter"
Lawrence H. Freeman, Jr.
Riverside, California
Sewer line cleaning, 1972

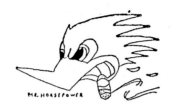

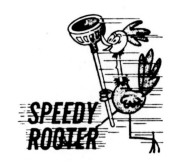

Happy History, Inc.
Boca Raton, Florida
Educational books, 1976

"Red Robin"
Red Robin Enterprises, Inc.
Seattle, Washington
Restaurant services, 1976

"St. Louis Cardinal"
St. Louis National Baseball Club
St. Louis, Missouri
Baseball games, 1979

"Sam"
Los Angeles Olympic Organizing Committee
Los Angeles, California
Olympic mascot, 1980

The Tournament Players Association
Sawgrass, Florida
Books relating to golf, 1981

Louisiana World Exposition, Inc.
New Orleans, Louisiana
International exposition. 1982

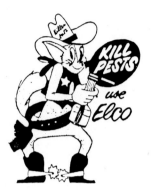

"Puss 'n' Boots"
Coast Fishing Company
Wilmington, California
Canned cat food, 1934

"Cat Eye"
Tsuyama Mfg. Company
Osaka, Japan
Lights for cycles, 1957

"Killer Katz"
Elco Mfg. Company
Pittsburgh, Pennsylvania
Pesticides, 1968

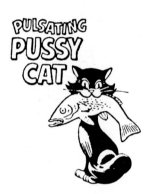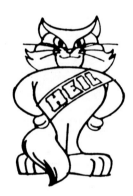

"Pulsating Pussy Cat"
Commanche Tackle Company
Brentwood, New York
Fishing lures, 1976

"El Gato"
C & C Services, Inc.
Cucamonga, California
Restaurant services, 1977

"Heil Cat"
The Heil Company
Milwaukee, Wisconsin
Refuse collection trucks, 1979

Excel-Mineral Company, Inc.
Goleta, California
Cat litter, 1984

"Felix"
Felix The Cat Productions, Inc.
Woodcliff Lake, New Jersey
T-Shirts, 1982

BYP Corporation
Charlotte, North Carolina
Shampoo, 1983

"The Quick Brown Fox"
SCM Corporation
New York, New York
Typewriters, 1964

"Red Fox"
Red Fox Cafe
Bismarck, North Dakota
Restaurant services, 1973

"Foxy"
Bud's Wholesale Distributor, Inc.
Downey, California
Hamburger patties, 1963

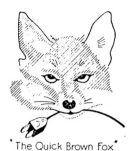

"The Quick Brown Fox"

"Foxxy"
Foxxy, Inc.
Sparta, Wisconsin
Advertising newspapers, 1976

Wegerly Broadcasting Corporation
Flint, Michigan
Radio broadcasting, 1983

Pine Tree Industrial Corporation
Upland, California
Motel services, 1981

"Foxy Feelgood"
Health Enterprises, Inc.
Pine, Colorado
Game equipment, 1977

The Organizing Committee of the XIV Olympic Winter Games
Sarajevo, Yugoslavia
Olympic mascot, 1982

Hoker Broadcasting, Inc.
Dallas, Texas
Radio broadcasting, 1988

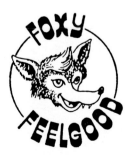

"Camera Bug"
Camera Bug, Inc.
Sepulveda, California
Retail camera store, 1973

"Bunny Luv"
Mike Yurosek & Son
Newhall, California
Carrots, 1971

"Mr. Flea"
Ray Acord
Sunrise, Florida
Flea market, 1979

"Brer Rabbit"
Penick & Ford, Ltd.
New Orleans, Louisiana
Molasses, 1946

"Brother Rabbit"
**Nationwide Dispatch &
Storage Co.**
Hartford, Connecticut
Moving van service, 1950

"Trix"
General Mills, Inc.
Minneapolis, Minnesota
Breakfast cereal, 1960

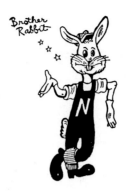

"Daddy Rabbit"
Daddy Rabbit's Campground
Willis, Virginia
Campground facilities, 1977

"Topper"
Topper's Presto Prints, Inc.
Fern Park, Florida
Printing services, 1978

"Bleyer Rabbit"
Bleyer Industries, Inc.
Lynbrook, New York
Easter egg decorations, 1983

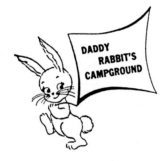
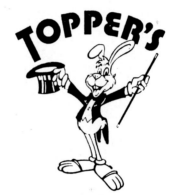
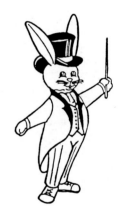

"Gigi"
Toys "R" Us, Inc.
Rochelle Park, New Jersey
Children's toys, 1974

"Happy"
Child World, Inc.
Avon, Massachusetts
Children's toys, 1975

"Junior"
Toys "R" Us, Inc.
Rochelle Park, New Jersey
Children's toys, 1979

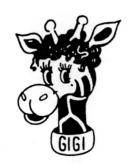
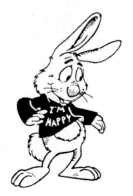
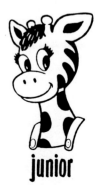

Tape Head Company
Salt Lake City, Utah
Tape decks, 1971

Pzazz, Inc.
Burlington, Iowa
Restaurant services, 1972

Ratskeller, Inc.
Government Camp, Oregon
Restaurant services, 1969

Frito-Lay, Inc.
Dallas, Texas
Cheese flavored snacks, 1973

Ralston Purina Company
St. Louis, Missouri
Cat food, 1978

"Antoine"
Ziekenhuis Diensten Groep B.V.
Zeist, Netherlands
Paper napkins and bags, 1982

The Swiss Colony, Inc.
Monroe, Wisconsin
Meats and processed foods, 1980

Kellogg Company
Battle Creek, Michigan
Breakfast cereal, 1980

Claber S.P.A.
Via Pontebbana, Italy
Art store services, 1983

"Barney Beaver"
DeKalb Federal Savings & Loan
Decatur, Georgia
Savings and loan services, 1976

"Woody"
Woody's Superettes, Inc.
Greenville, Texas
Grocery store services, 1969

Beaver Coaches, Inc.
Bend, Oregon
Recreational vehicles, 1967

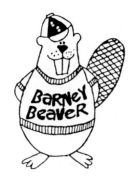

Chisum Log Mill
Claremore, Oklahoma
Assistance in establishing log
producing plants, 1974

Mann's Equipment Mfg., Inc.
Arlington, Washington
Construction equipment, 1979

Essex Specialty Products, Inc.
Clifton, New Jersey
Polyurethane sheeting, 1986

Beaver Tails, Inc.
Aspen, Colorado
Fried pastry mix, 1985

"Ozzie Otter"
Pacific Waterslides, Inc.
Birch, Washington
Amusement services, 1982

Beecham, Inc.
Clifton, New Jersey
Dental care kits, 1979

Boy Scouts of America
Dallas, Texas
Award certificates, 1950

Kellogg Company
Battle Creek, Michigan
Breakfast cereal, 1950

"Esso Tiger"
Humble Oil & Refining Company
Tulsa, Oklahoma
Gasoline, 1959

California Western Railroad
Fort Bragg, California
Rail transportation, 1965

Crackerbarrel Sales Company
Buffalo, New York
Deodorant, 1974

Lockheed California
Burbank, California
Aircraft design, 1984

Gator Paint, Inc.
Oakland, Florida
Paint, 1979

"Dynamark Dan"
Dynamark Security Centers
Hagerstown, Maryland
Security systems, 1984

Ellis Cormier
Jennings, Louisiana
Restaurant services, 1982

Blue Chip Stamps
Los Angeles, California
Trading stamps, 1956

A.A. Ability Lock & Key Service
New York, New York
Locksmith services, 1979

Green Gables Nut Farms
Phoenix, Arizona
Retail fruit and nut sales, 1981

"Connie"
Continental Oil Company
Wilmington, Delaware
Energy conservation
promotion, 1975

"Spunky"
American Forestry Association
Washington, D.C.
Tree conservation promotion, 1982

"Earthworm"
North American Bait Farms, Inc.
Ontario, California
Worm consultants, 1975

"Sambo Tiger"
Sambo's Restaurants
Santa Barbara, California
Restaurant services, 1975

Walgreen Company
Deerfield, Illinois
Restaurant services, 1977

"Ringo"
Family Leisure Centers, Inc.
Cincinnati, Ohio
Children's rings, 1973

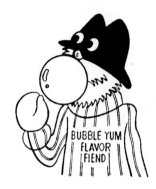

"*Hi-Fi Fo-Fum*"
Hi-Fi Fo-Fum, Inc.
Milwaukee, Wisconsin
High fidelity equipment, 1959

"*Little Emo*"
Emo Productions
Montecito, California
Musical entertainment, 1971

"*Bubble Yum Flavor Fiend*"
Life Savers, Inc.
New York, New York
Confections, 1976

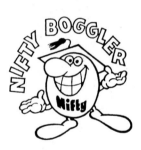

LITTER CRITTER

"*Nifty Boggler*"
St. Regis Paper Company
New York, New York
School writing pads, 1979

"*Litter Critter*"
Golden Recycle Company
Lakewood, Colorado
Aluminum can recycling, 1978

"*Chlorine Bill*"
Aquadyne, Inc.
Salt Lake City, Utah
Chlorine equipment, 1974

"*Grundle*"
Central Maine Power Company
Augusta, Maine
Conservation education, 1983

"*Spoto*"
Mark Enterprises
Costa Mesa, California
Spot and stain remover, 1983

"*Rat Fink*"
Edward Roth
La Mirada, California
Key chains, 1986

"Snoopy"
United Feature Syndicate, Inc.
New York, New York
Cookies and ice cream, 1984

"Mother Mousse"
Mother Mousse, Ltd.
Staten Island, New York
Pies and cakes, 1985

"Freddie Boomer"
Freddie Boomer, Inc.
Woodland Hills, California
Powder mixes, 1987

"King Comp"
Rogers-Design
Houston, Texas
Layouts and storyboards, 1987

"Gorilla"
Leading Edge Products, Inc.
Canton, Massachusetts
Computer peripherals, 1983

"King Gong"
Steve Weiss Music
Philadelphia, Pennsylvania
Gongs and cymbals, 1987

"Grease Monkey"
Grease Monkey International
Denver, Colorado
Automotive lubrication
centers, 1978

"Mr. Bubbles"
Mr. Bubbles Auto Wash, Inc.
Palm Beach, Florida
Car wash services, 1988

"Beach Rat"
Beach Rat, Inc.
Santa Monica, California
Back packs, 1986

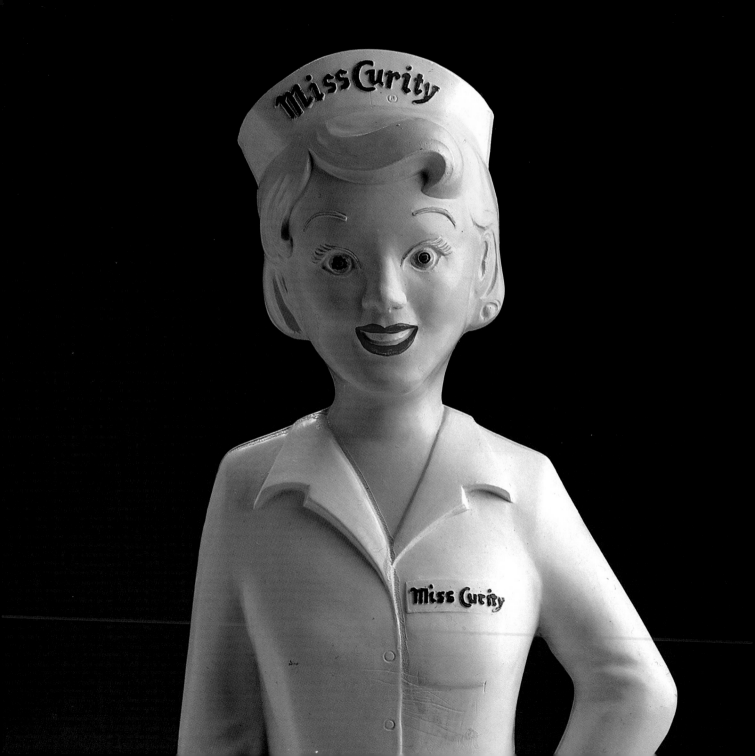

Female Character Marks

Discovered in a small Paris antique shop, the figure of *Miss Curity* represents the quintessential female character trademark. Dressed in a crisp white nurse's uniform, she stands erect with blue eyes and blond hair, advertising "hospital quality" medical products. Who could resist her smile, stiff as it may be? Originally purchased by a French collector in the United States, she is now back in her homeland after surviving two trans-Atlantic voyages.

From *Aunt Jemima*, the original 1905 design shown here, to the 1982 *Merrie Metric*, provocatively posed in a bikini, female forms have been used as trade characters in a variety of ways. Like *Betty Crocker*, they typically are enlisted to sell homemaker products and services. Their zenith was in the 1950s, when female characters such as Miss Curity enjoyed widespread popularity. Rendered in the kitschy commercial art style of the period, they represent a time when women generally stayed home to cook, clean and take care of their families.

Companies today are faced with a dilemma: how to represent women in a way that is not outdated, sexist or both. Unfortunately, as a result of this dilemma, the use of the female trade character has declined precipitously. In an effort to avoid controversy, all but the most innocuous use of the female has been shunned in favor of the male character mark. Women in the world of trademarks, as in the world at large, have not yet reached parity with men. When Miss Curity the nurse becomes Ms. Curity the doctor, we will know that some progress has occurred. Until that time, it appears that except for use on food packaging the female character trademark is headed for oblivion.

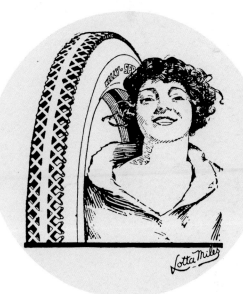

Lotta Miles sold Kelly-Springfield automobile tires throughout the 1920s: "There's a lotta smiles in a lotta miles when using Kelly tires."

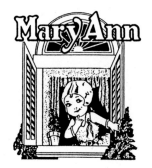

"Mrs. Tucker"
Interstate Cotton Oil Refining Co.
Sherman, Texas
Canned fruits and vegetables, 1913

"Sun-Maid"
Sun-Maid Growers of California
Kingsburg, California
Raisins and fruit juices, 1915

"Mary Ann"
The Fremont Mills
Omaha, Nebraska
Wheat flour, 1926

"Creamette Girl"
The Creamette Company
Minneapolis, Minnesota
Alimentary pastes, 1926

"Connie Colman"
Atlantis Sales Corporation
Rochester, New York
Mustard, 1945

"Laura Lovell"
Lovell Mfg. Company
Erie, Pennsylvania
Washing machine wringers, 1946

"Dazey De Luxe"
Dazey Corporation
St. Louis, Missouri
Can openers, 1946

"Towie"
Belle Products Company, Inc.
Houston, Texas
Packaged onions, 1948

"Sally Shopwell"
Shopwell Foods, Inc.
Pelham Manor, New York
Tea, coffee and eggs, 1951

"Beatrice Cooke"
Beatrice Foods Company
Chicago, Illinois
Food products, 1952

"Oleo Maid"
Standard Brands, Inc.
New York, New York
Oleomargarine, 1953

"Miss Kool Kooshion"
Kool Kooshion Mfg. Company
Oklahoma City, Oklahoma
Fabricated cushions, 1955

"Lady Presco"
Pressing Supply Company
Philadelphia, Pennsylvania
Ironing board pads, 1956

"Thin Twins"
Thin Twins Potato Chip Corporation
Evansville, Indiana
Potato chips, 1956

"Sharin Profit"
The Kroger Company
Cincinnati, Ohio
Profit-sharing plan promotion, 1957

"Marie"
Marie's, Inc.
Seattle, Washington
Salad dressing, 1958

"Maria"
Bison Products, Inc.
Buffalo, New York
Hard salami and pepperoni, 1958

"Patty Piper"
Bake-Rite Baking Company
Stevens Point, Wisconsin
Bakery products, 1958

 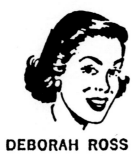

"Maid Rite"
Maid-Rite Steak Company, Inc.
Scranton, Pennsylvania
Frozen meat products, 1960

"Deborah Ross"
The Manischewitz Company
Newark, New Jersey
Matzo crackers, 1960

"Molly"
Molly Corporation
Temple, Pennsylvania
Screw anchors, 1963

 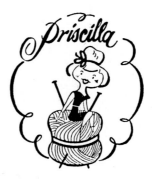

"Connie Contact"
United Merchants & Mfrs., Inc.
New York, New York
Adhesive coated contact
paper, 1964

"Snow Queen"
East Asiatic Company, Inc.
New York, New York
Packaged rice, 1967

"Priscilla"
**Orchard Yarn and
Thread Company**
New York, New York
Yarns, 1968

 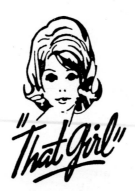

"Nancy Austin"
Nancy Austin Fashion Parlor
Las Vegas, Nevada
Women's clothing, 1970

"That Girl"
Jewel Masters, Inc.
Providence, Rhode Island
Jewelry, 1970

"Auntie Litter"
Chris Enterprises, Inc.
Zion, Illinois
Anti-litter campaigns, 1972

Betty Crocker

In 1921, the Washburn Crosby Company, a forerunner of General Mills, created the *Betty Crocker* name to be used in replies to homemakers' letters and requests for recipes. Betty's career expanded in 1924 when her voice was heard on daytime radio's first food service program, the Betty Crocker "Cooking School of the Air" that ran for twenty-four years. Her first official portrait was commissioned in 1936; it has been updated five times since. As early as 1940, surveys indicated that 90% of the American public recognized the Betty Crocker name. She has come to symbolize warmth, service, reliability and quality, making her one of the best known characters ever created by an American company.

From left to right below are the portraits of *Betty Crocker* introduced by General Mills from 1936 to 1980.

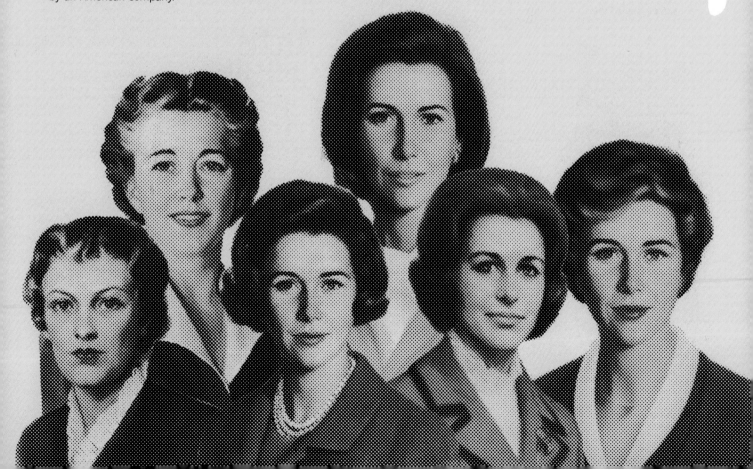

BAR B CUTIE

Barby Que

"Bar B Cutie"
James E. McFarland
Nashville, Tennessee
Restaurant services, 1950

"Barby Que"
Auto-Dine
Bismarck, North Dakota
Barbecue sauce, 1970

"Indian Maid"
Land O'Lakes, Inc.
Arden Hills, Minnesota
Margarine, 1971

Jiffy Jenie

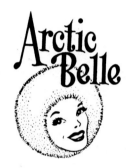

Arctic Belle

"Jiffy Jenie"
Jiffy Jenie Printing Center
Centereach, New York
Printing services, 1972

"Mama Celeste"
The Quaker Oats Company
Chicago, Illinois
Frozen prepared foods, 1973

"Arctic Belle"
Clinebell Service Company
Loveland, Colorado
Packaged ice, 1974

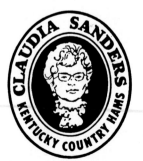

"Claudia Sanders"
**Claudia Sanders Kentucky
Country Hams**
Cecilia, Kentucky
Ham, 1974

"Ladie Laurie"
Ladie Laurie Sew-A-Mats, Inc.
Elmhurst, Illinois
Coin operated sewing
machines, 1974

"Lydia E. Pinkham"
Cooper Laboratories, Inc.
Bedford Hills, New York
Medicines, 1974

"Chicken of the Sea Mermaid"
Ralston Purina Company
St. Louis, Missouri
Canned tuna, 1974

"Lady Butcher"
Red Steer Meats
Phoenix, Arizona
Beef products, 1975

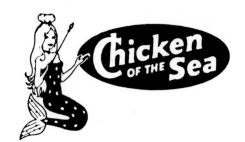

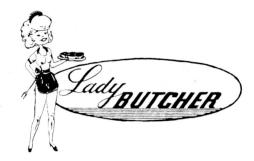

"Bella Ross"
J. & B. Ross, Inc.
Brunswick, New Jersey
Furniture, 1979

"Margie"
Concel, Inc.
Great Neck, New York
Toilet tissue, 1979

"Happy Hardman"
Hardman Supply Company, Inc.
Spencer, West Virginia
Hardware store services, 1980

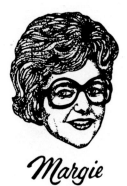

"Merrie Metric"
Merrie Metric Enterprises
Farmington, Michigan
Promotion of the metric
system, 1982

"Mother Nature"
Nature's Best, Inc.
Torrance, California
Fruit juice, 1983

"Fanny Farmer"
Fanny Farmer Candy Shops, Inc.
Bedford, Massachusetts
Candy, 1985

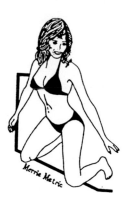

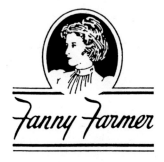

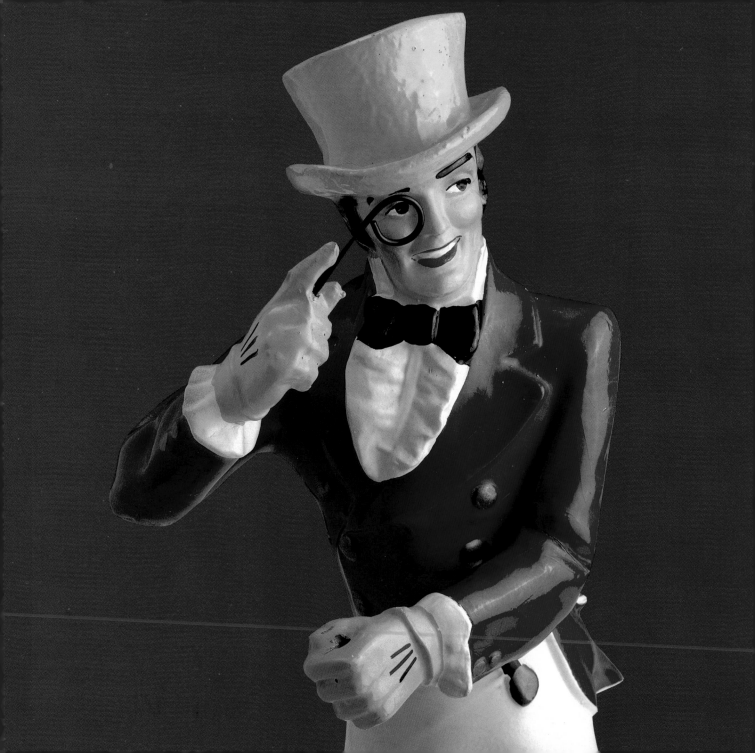

Male Character Marks

Men have dominated the genre of character trademarks as they have the world of business. From the *Jolly Green Giant* to the *Electrolux Man*, male figures have come to represent all manner of goods to a consuming public. Personifying wholesomeness, honesty, friendliness and strength, these trade characters have made an indelible mark on America's conscious.

The earliest such figure, the *Quaker Oats Man,* has been in use for over a century. He was originally created in 1877 for a small oatmeal milling company in Ravena, Ohio; both owners of the business took credit for inventing him. The purity and wholesomeness of the Quakers made the Quaker Oat Man a perfect selection for a food manufacturing company. Over the years he has been redesigned and modernized, but none of the subsequent renditions has the charm of the original engraving.

Although some character marks are based on real people, such as *Johnny Walker* or *Orville Redenbacher,* most are purely imaginary. The 1920s and 1930s saw a veritable explosion of these fictional figures. Chefs, aristocrats, kings and ordinary sales pitchmen all debuted at a dizzying pace as more companies competed for market share. These symbols reveal some of the racial and cultural stereotypes of the era.

A peculiarly American tradition is for a company to use a "Mr." as a trade character. These run the gamut of products, from *Mr. Whipple* for toilet paper to *Mr. Meatball* for a restaurant. Chefs are still the first choice of food industries; while the use of kings is on the decline, superheroes appear to be gaining popularity. Character marks, like so much else in our culture, are subject to the vagaries of the times.

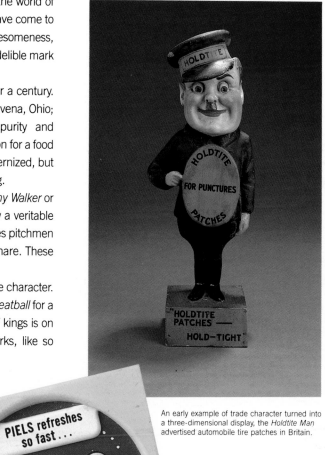

An early example of trade character turned into a three-dimensional display, the *Holdtite Man* advertised automobile tire patches in Britain.

The strolling figure of *Johnny Walker,* created in 1820 for John Walker & Sons, distillers in London, has been used over the years as an advertising display for pubs and taverns. The version shown here dates from the 1960s.

Bert and Harry were sales pitchmen for the Piel Brothers Brewing Company of Brooklyn, New York. Their likenesses appeared on all types of promotional material during the 1950s, including beer trays and coasters.

PIELS refreshes so fast...

You need a stop-watch to time it!

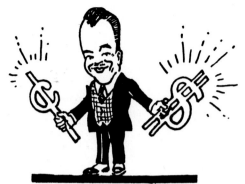

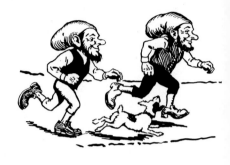

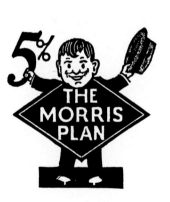

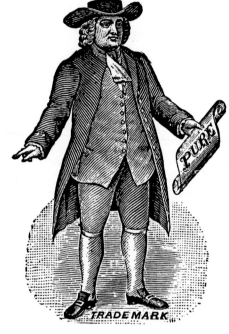

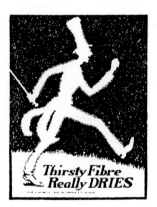

"Saving Sam"
The Western Auto Company
Los Angeles, California
Automotive supplies, c. 1925

"The Quaker Oats Man"
The Quaker Oats Company
Chicago, Illinois
Oatmeal, 1877

"Hammacher Schlemmer Gnomes"
Hammacher, Schlemmer & Co.
New York, New York
Retail hardware stores, c. 1927

"Mr. Five Percent"
The Morris Plan Bank
New York, New York
Banking services, c. 1925

"Mr. Thirsty Fibre"
Scott Paper Company
Philadelphia, Pennsylvania
Paper towels, c. 1927

GLOU-GLOU
Fils de Nectar

"Nectar"
Etablissements Nicolas
Charenton-le-Pont, France
Retail grocery stores, 1933

"Esky"
Esquire
New York, New York
Magazine, 1935

"Glou-Glou"
Etablissements Nicolas
Charenton-le-Pont, France
Retail grocery stores, 1932

"Esky"
Esquire
New York, New York
Magazine, 1935

"The Hills Brothers Turk"
Hills Brothers Coffee Company
San Francisco, California
Coffee, 1954

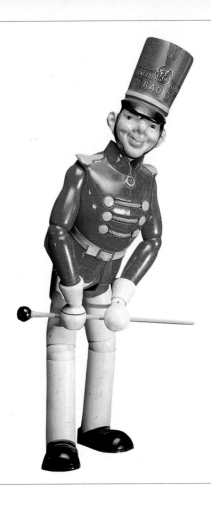

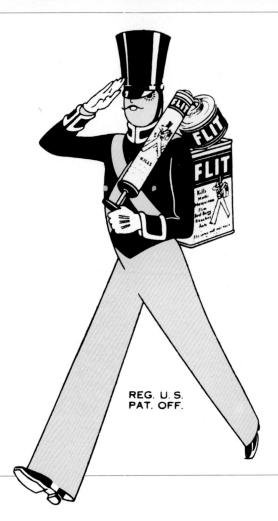

REG. U. S.
PAT. OFF.

"Bandy"
General Electric Company
New York, New York
Light bulbs, c. 1930

"Flit Soldier"
Stanco Inc.
Bayway, New Jersey
Insecticides, c. 1935

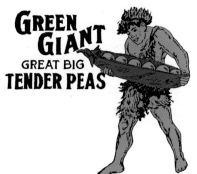

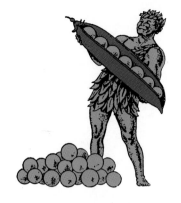

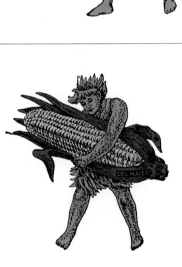

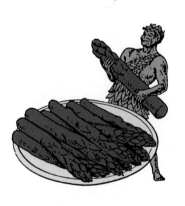

"The Jolly Green Giant"
**Minnesota Valley
Canning Company**
Le Sueur, Minnesota
Canned peas, 1926
Canned corn, 1932
Canned peas, 1936
Canned asparagus, 1939

Canned vegetables, 1975

"Little Sprout"
Canned baby peas, 1975

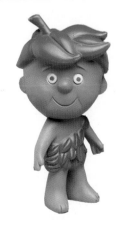

"Butcher's Friend"
Todd's Inc.
Des Moines, Iowa
Meat preservatives, 1928

"Hot Dan the Mustard Man"
The R.T. French Company
Rochester, New York
Mustard, 1936

"Lester"
Milgram Food Stores, Inc.
Kansas City, Missouri
Retail grocery stores, 1946

Trunz, Inc.
Brooklyn, New York
Ham and bacon, 1940

"El Chico"
El Chico Cafe
Dallas, Texas
Restaurant services, 1940

"Otto"
A. Gusmer, Inc.
Hoboken, New Jersey
Cleansers, 1943

We live to kill — Bugs!

Western Exterminator Company
Los Angeles, California
Pest control services, 1937

"Doc Kilzum"
Paramount Pest Control Service
Oakland, California
Pest control services, 1938

Skil-Craft Corporation
Chicago, Illinois
Hand tools, 1949

"Handy Andy"
Handy Andy TV & Appliances, Inc.
Sacramento, California
Household appliances, 1953

"Kerr-McGee Serviceman"
Kerr-McGee Oil Industries, Inc.
Oklahoma City, Oklahoma
Automobile maintenance, 1957

"Pako"
Pako Photo, Inc.
Minneapolis, Minnesota
Film processing, 1959

"FMC Man"
FMC Corporation
San Jose, California
Auto servicing equipment, 1960

"Andy"
Anderson Electric Corporation
Leeds, Alabama
Electrical supplies, 1962

"Happy Tappy"
Rust-Lick, Inc.
Boston, Massachusetts
Tapping fluid, 1962

"The Good Humor Man"
Good Humor Corporation
Brooklyn, New York
Ice cream, 1962

"Kern'l Kooky"
The Quaker Oats Company
Chicago, Illinois
Breakfast cereal, 1963

"Reddi"
Reddi Wip Company
Philadelphia, Pennsylvania
Whipped cream, 1967

"The Ham What Am Man"
Armour Star Company
Chicago, Illinois
Ham and bacon, c. 1925

"Cream of Wheat Chef"
The Cream of Wheat Corporation
Minneapolis, Minnesota
Wheat breakfast food, 1938

"Salerno Chef"
Salerno-Megowen Biscuit Co.
Chicago, Illinois
Crackers and cookies, 1937

"Hera"
**Sociètè des Produits
d'Alimentation**
Paris, France
Bakery goods, 1934

"Chef Boy-Ar-Dee"
Chef Boy-Ar-Dee Foods
New York, New York
Canned spaghetti, 1945

"Spry Baker"
Lever Brothers Company
Cambridge, Massachusetts
Vegetable shortening, c. 1945

"Premier Chef"
Premier Foods, Inc.
Boston, Massachusetts
Shortening, 1950

"Hap-pea and Pea-wee"
Andersen's Foods, Inc.
Buellton, California
Canned soups, 1950

"Colonel Sanders"
Kentucky Fried Chicken Corp.
Shelbyville, Kentucky
Restaurant services, 1952

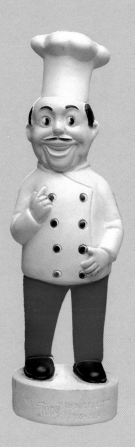

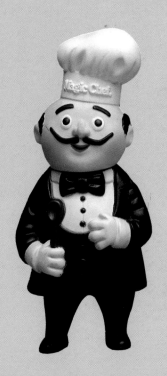

"Bertolli Chef"
F. Bertolli
Lucca, Italy
Olive oil, c. 1950

"Mr. Tony"
(Company Unknown)
The world's best frozen
pizza, c. 1955

"Magic Chef"
Magic Chef, Inc.
Cleveland, Ohio
Gas ranges, 1961

"Rokie"
I. Rokeach & Sons, Inc.
New York, New York
Vegetable oil, 1953

Willmark Sales Company
Brooklyn, New York
Baking supplies, 1953

"Grill King"
American Vending Corporation
Oakbrook, Illinois
Sandwich vending machines, 1953

"Churchie"
Church's Fried Chicken, Inc.
San Antonio, Texas
Restaurant services, 1955

"Sunshine Baker"
Sunshine Biscuits, Inc.
New York, New York
Bakery goods, c. 1955

"Jack Miller"
Jack D. Miller
Ville Platte, Louisiana
Barbecue sauce, 1955

"Coffee Dan"
Coffee Dan's, Inc.
Los Angeles, California
Coffee shop services, 1956

"Mr. Biscuit"
Statesville Flour Mills Company
Statesville, North Carolina
Flour, 1960

"Pepe Roni"
Valians, Inc.
Restaurant services, 1960

"Pizza Hut Pete"
Pizza Hut, Inc.
Wichita, Kansas
Restaurant services, 1960

"Pioneer Pete"
Pioneer Take Out Corporation
Los Angeles, California
Restaurant services, 1961

"Chico"
Chico's Pizza Franchises, Inc.
Portland, Oregon
Restaurant services, 1961

Farmer Brothers Company
Torrance, California
Coffee brewing machines, 1964

"Mr. B"
B.B. Foods Corporation
Akron, Ohio
Frozen onion rings, 1964

"Walt"
Laura Kingston, Inc.
Cranston, Rhode Island
Carry-out restaurants, 1967

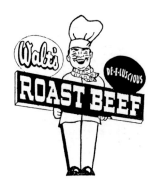

"Pizza Pieman"
Darnoth Enterprises, Ltd.
Victoria, Canada
Pizza pies, 1967

"McBurger"
McCrory Corporation
New York, New York
Restaurant services, 1968

"Mr. B"
Barro's Pizza
El Monte, California
Restaurant services, 1971

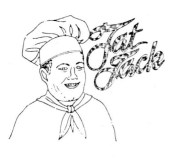

"Fat Jack"
Fat Jack's Enterprises
Bellflower, California
Barbecue sauce, 1971

"Jolly Chef"
Jolly Chef Foods, Inc.
Alexandria, Virginia
Pork sausages, 1972

"Hot Sam"
Hot Sam, Inc.
Southfield, Michigan
Pretzels, 1973

"Wally Waffle"
Wally Waffle, Inc.
Akron, Ohio
Restaurant services, 1975

"Chef U.F."
Universal Foods Corporation
Milwaukee, Wisconsin
Imitation cheese, 1976

"Pudgie"
Pudgie's Pizza Franchising
Elmira, New York
Restaurant services, 1977

The Midwest Pizza Corp.
Woodridge, Illinois
Restaurant services, 1974

"Chef Paul"
Paul E. Prudhomme
New Orleans, Louisiana
Seasonings, 1982

"Chef Merito"
Chef Merito, Inc.
Chatsworth, California
Seasonings, 1984

trayed by college students who travers the country in four Weinermobiles.

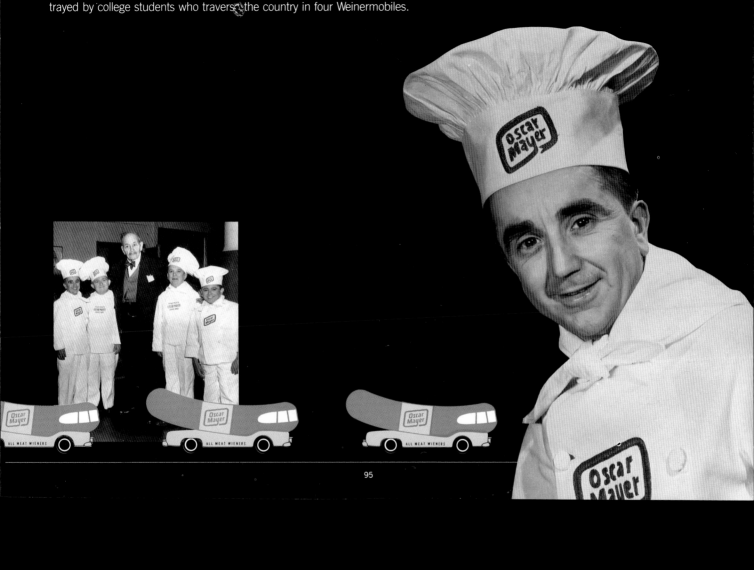

"Cisco"
Cisco Foods, Inc.
Montebello, California
Tortillas, 1944

El Molino Foods, Inc.
Denver, Colorado
Prepared Mexican foods, 1949

"Gordo"
Gordo's Mexican Food Products
Phoenix, Arizona
Frozen enchiladas, 1955

"Poncho"
Poncho's, Inc.
Portland, Oregon
Restaurant services, 1964

B.F. Trappey's Sons, Inc.
New Iberia, Louisiana
Beans, 1968

"Jon Piedro"
Brick-Hanauer, Inc.
Watertown, Massachusetts
Cigars, 1971

"Butcher Boy"
Butcher Boy Food Products, Inc.
Riverside, California
Mexican meat products, 1971

"Jupiter"
Ricardo's Salsa Company
Temple City, California
Meatless sauce, 1972

"Tapatio"
Jose Luis Saavedra
Maywood, California
Hot sauce, 1977

"Mac Economy"
Economy Auto Stores, Inc.
Atlanta, Georgia
Electric generators and
batteries, 1941

"Thrifty Dan the Photo Man"
Muir Photo Company
Grand Rapids, Michigan
Photo processing services, 1948

Skunk Mfg. Company, Inc.
Bucyrus, Ohio
Metal blades, 1957

"Canny Scot"
Paul Mariani Company
Cupertino, California
Dried fruit, 1960

"Scotty"
Scotty's Home Builders Supply
Winter Haven, Florida
Lawn and garden tools, 1969

"Scottie"
Scottie Stores, Inc.
Jacksonville, Florida
Retail variety stores, 1970

"Cashe Earnsmore"
**First Federal Savings
& Loan Assoc.**
East Chicago, Indiana
Banking services, 1972

"Thrifty Scot"
Thrifty Scot Motels, Inc.
St. Cloud, Minnesota
Motel services, 1973

"The Power Miser"
Intertherm, Inc.
St. Louis, Missouri
Air conditioner dampers, 1976

Cashe Earnsmore

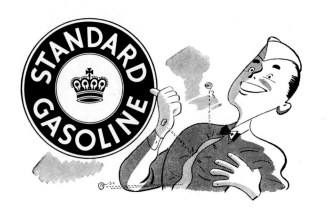

*"Stan, Your Standard
Service Man"*
Standard Oil of California
Los Angeles, California
Gasoline, 1942

"Dick Elliott"
Dick Elliott and Associates
Logansport, Indiana
Advertising newspapers, 1930

"Old Baldy"
**The Koch Butchers'
Supply Company**
North Kansas City, Missouri
Hog hair removal compound, 1946

"Peter Putter"
Schalk Chemical Company
Los Angeles, California
Tile adhesive, 1955

"Trojan"
Michigan State University
East Lansing, Michigan
Athletic events, 1955

"Dixie Dandy"
Fleming Companies, Inc.
Oklahoma City, Oklahoma
Retail supermarket services, 1958

"Uncle Josh"
Uncle Josh Bait Company
Fort Atkinson, Wisconsin
Fishing baits, 1959

"Captain Crunch"
The Quaker Oats Company
Chicago, Illinois
Breakfast cereal, 1963

"Duro Dan"
Duro Art Industries, Inc.
Chicago, Illinois
Art supplies, 1973

"Transformer Charley"
S.D. Myers, Inc.
Akron, Ohio
Electrical equipment, 1973

"Hardware Hank"
United Hardware Distributing Company
Minneapolis, Minnesota
Retail hardware store services, 1975

"Good Sam"
Trailer Life Publishing Company
Calabassas, California
Trailer park services, 1976

"Spartan"
Flowers Industries, Inc.
Thomasville, Georgia
Bread and rolls, 1975

"Hosenose"
Industries Trade-X
Van Nuys, California
Industrial products, 1977

"Sir Speedy"
Sir Speedy, Inc.
Newport Beach, California
Duplicating services, 1977

"Pop Larsen"
Builders Emporium
Irvine, California
Home Improvement consulting, 1979

"Kaleidoscope Man"
Daniel M. Poppers
Tahoe City, California
Posters, 1979

"Arnie"
Arno Adhesive Tapes, Inc.
Michigan City, Indiana
Adhesive coated tapes, 1957

"Tuf Boy"
Blodgett Enterprises
Enterprise, Alabama
All-purpose detergent, 1970

"Sien Brute"
Sien Equipment Company
Carlsbad, New Mexico
Mine vehicles, 1973

"Fault Fiter"
S & C Electric Company
Chicago, Illinois
High voltage fuses, 1974

Gold's Gym Enterprises, Inc.
Venice, California
Gymnasium services, 1973

"The Gentle Big Guy"
King Van & Storage, Inc.
Anaheim, California
Moving services, 1969

"Hercules"
Hercules Service Corporation
Johnstown, Pennsylvania
Automobile rustproofing, 1974

"Big Tate"
The R.T. French Company
Rochester, New York
Instant potato mix, 1976

"Giant"
Giant Realty Franchising, Inc.
Rochester, New York
Real estate brokerage
services, 1980

"The Big Canadian"
Ed. Phillips & Sons Company
Minneapolis, Minnesota
Canadian whiskey, 1970

"Earl"
Earl's Supply Company
Carson, California
Hydraulic hoses, 1972

"Aqua Genie"
Jacuzzi Brothers, Inc.
Little Rock, Arkansas
Automatic water systems, 1971

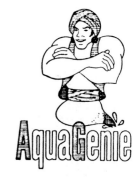

"Jimbo"
Jimbos Frozen Foods, Inc.
Minneapolis, Minnesota
Sandwiches and pizza, 1977

"Tuff Kote"
Tuff-Kote Dinol, Inc.
Warren, Michigan
Automobile rustproofing, 1979

"Bubbs"
Blair Industrial Uniforms
Houston, Texas
Uniforms and workwear, 1981

"The Grout Man"
Cambrian Foundation, Inc.
King of Prussia, Pennsylvania
Grouting equipment, 1983

"Savin' Sam"
Hill Behan Lumber Company
St. Louis, Missouri
Retail lumber yard services, 1985

"Willy Eatmore"
Don Enterprises, Inc.
Miami, Florida
Coffee mugs and
paper plates, 1985

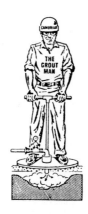
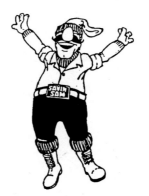

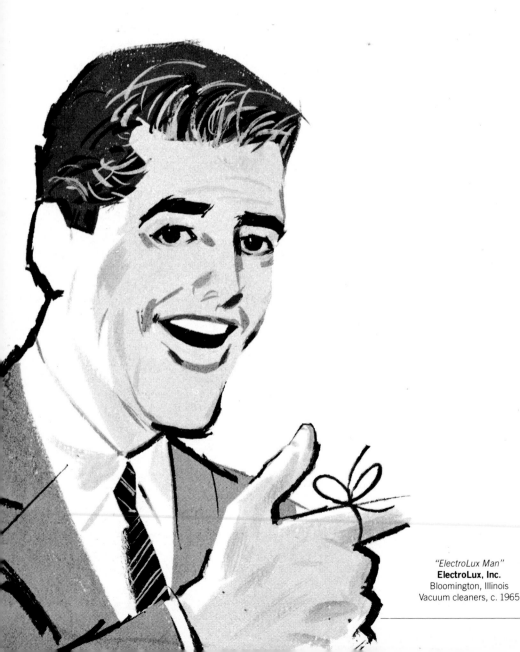

"The Chamberlin Man"
Chamberlin Co. of America
Detroit, Michigan
Storm windows, 1947

"Sco-Joe"
Schofield Mfg. Company
Cleveland, Ohio
Sheet metal panels, 1957

"Speedy"
Local Trademarks, Inc.
New York, New York
Advertising services, 1960

"Martin"
Martin Sprocket & Gear, Inc.
Arlington, Texas
Machine shop services, 1963

"Mr. V.I.P."
V.I.P. Travel Service, Inc.
Chicago, Illinois
Travel agency services, 1965

"Mr. Friendly"
Hardware Wholesalers, Inc.
Fort Wayne, Indiana
Hardware distribution, 1970

"Mr. Print"
Graphco, Inc.
Crystal, Minnesota
Printing services, 1970

"The Price Slasher"
B & J Agents, Inc.
Riverside, California
Automobile dealership
services, 1971

"Mr. Goodbuy"
Hair Enterprises
Farmington, New Mexico
Retail furniture sales, 1980

"Reddie Eddie"
Hodge Mfg. Company, Inc.
Springfield, Massachusetts
Material handling equipment, 1980

"The Hathaway Man"
Warnaco, Inc.
Bridgeport, Connecticut
Cologne, 1980

"ElectroLux Man"
ElectroLux, Inc.
Bloomington, Illinois
Vacuum cleaners, c. 1965

"Bob"
The SubGenius Foundation
Dallas, Texas
Pseudo-religious icon, 1980

SCO-JOE
The Schofield
Bodyman

Martin

MR. V.I.P.

Mr Friendly

the Price Slasher

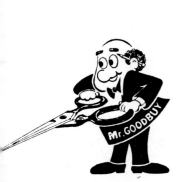

Mr. GOODBUY

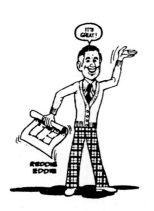

IT'S GREAT!

REDDIE EDDIE

"The Service Pro"
Intertherm, Inc.
St. Louis, Missouri
Schools for mechanics, 1969

"Sewer Man with a Conscience"
Rotary De-Rooting, Inc.
North Las Vegas, Nevada
Sewer cleaning services, 1967

"General"
General Sewer Services, Inc.
Staten Island, New York
Sewer cleaning services, 1968

"Handy Andy"
Western Publishing Company, Inc.
Racine, Wisconsin
Hand tool sets, 1977

"Ol' Lonely"
Maytag Company
Newton, Iowa
Washing machines, 1980

"Tinker Tyler"
The Emery-Waterhouse Company
Portland, Maine
Retail hardware store
services, 1974

"Tuffy"
American Castings Corporation
Chicago, Illinois
Insulative mastics, 1979

"Stanley Statistic"
Torx Products
Rochester, Indiana
Statistical control newsletter, 1984

"Dr. Tune"
Tru, Inc.
Houston, Texas
Automotive tune-up services, 1976

"Marx Elf"
Louis Marx & Company
New York, New York
Children's toys, 1959

"Usinger Elf"
Fred Usinger, Inc.
Milwaukee, Wisconsin
Packaged sausages, 1976

"Keebler Elf"
Keebler Company
Elmhurst, Illinois
Cookies and crackers, 1980

"Uncle Sam"
Bargain Town, U.S.A.
Birmingham, Alabama
Retail store services, 1975

"Uncle Sam"
Blake's Lotsaburgers, Inc.
Albuquerque, New Mexico
Restaurant services, 1978

"Uncle Sam"
Oshkosh B'Gosh, Inc.
Oshkosh, Wisconsin
Trousers, 1976

"Sir Casserole"
Sir Casserole, Inc.
Denver, Colorado
Restaurant services, 1975

"Sir Waxer"
Sir Waxer, Inc.
Milwaukee, Wisconsin
Automobile waxing services, 1975

"Little Friar"
Joy S. Golub
Oakhurst, New Jersey
Restaurant services, 1985

"Jo Jo"
J.L. Thompson Company
Salinas, California
Fresh vegetables, 1935

Golden Flake, Inc.
Birmingham, Alabama
Potato and corn chips, 1949

"Scoopy"
Keebler Company
Elmhurst, Illinois
Ice cream cones, 1949

The Pioneer Rubber Company
Willard, Ohio
Toy balloons, 1953

"Jack-in-the-Box"
Foodmaker, Inc.
San Diego, California
Restaurant services, 1950

"Jack-in-the-Box"
Foodmaker, Inc.
San Diego, California
Restaurant services, 1972

"Ronald McDonald"
McDonald's Corporation
Oak Brook, Illinois
Restaurant services, 1973

Harry London Candies, Inc.
North Canton, Ohio
Assorted candies, 1977

CPG Products Corporation
Minneapolis, Minnesota
Potato chips, 1978

"King of Pain"
Beecham, Inc.
Clifton, New Jersey
Ointment, 1896

"Rice King"
The Asia Company
Los Angeles, California
Rice, 1926

"King of Spuds"
Potato Products Corporation
Grand Forks, North Dakota
Potatoes and potato chips, 1935

KING OF PAIN

"Kitchen King"
H.B. De Viney Company, Inc.
New Bethlehem, Pennsylvania
Peanut butter, 1947

"Pizza King"
Vic Cassano's Pizza Provision
Dayton, Ohio
Pizzas, 1953

"King Midas"
King Midas Packing Company, Inc.
Philadelphia, Pennsylvania
Potatoes and onions, 1964

"The Rug Man"
The Rug Man, Inc.
Alexandria, Virginia
Carpets, 1973

"Ludwig the King"
Ludwig Motor Corporation
Melville, New York
Foreign automobile parts, 1968

"Pizza King"
Pizza King Enterprises, Inc.
Atlanta, Georgia
Restaurant services, 1968

"Burger King"
Burger King of Florida, Inc.
Jacksonville, Florida
Drive-in restaurant services, 1954

"Burger King"
Burger King Corporation
Miami, Florida
Restaurant services, 1980

"Appliance King"
Willis Appliance & TV, Inc.
Cleveland, Ohio
Appliances, 1981

"Burger King"
Burger King Corporation
Miami, Florida
Restaurant services, 1971

"The Lens King"
Wabash Wolk Camera Company
Chicago, Illinois
Retail camera store, 1977

"The King of Big Screen"
Paul's TV & Video
La Habra, California
Big screen televisions, 1989

Mr. Dee-lish

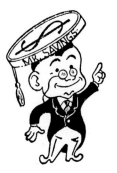

"THIS IS NO BUM STEER"

Mr. "K" SEZ-

HAVE NO FEAR MR. SEWER IS HERE!

MR. DRAINO

MR. TERMITE

"Mr. Sewer"
Mr. Sewer, Inc.
Brooklyn, New York
Sewer cleaning, 1968

"Mr. Draino"
Retail Security Service, Inc.
Milwaukee, Wisconsin
Security protection, 1969

"Mr. Termite"
Mr. Exterminating and Pest Control
Cynwy, Pennsylvania
Pest control services, 1970

BOB RULE
Mr. YoYo

MR. ASTRO

"Mr. Rooter"
Mr. Rooter Corporation, Inc.
Oklahoma City, Oklahoma
Sewer cleaning services, 1970

"Mr. Yo Yo"
Robert M. Rule
Atlanta, Georgia
Toy yo-yos, 1970

"Mr. Astro"
The Baxter Corporation
Paterson, New Jersey
Shipping bags, 1974

MR. YARD

Mr. Tuffy

"Mr. Yard"
L.E. Kenamer & Son
Scottsboro, Alabama
Thread, 1975

"Mr. Tuffy"
Mr. Tuffy Company
Manasquan, New Jersey
Tube protectors for tires, 1976

"Mr. Frostie"
The Frostie Company
Camden, New Jersey
Candy, 1976

"Mr. Goodmeat"
Hickman, Coward & Wattles, Inc.
Buffalo, New York
Frozen meat products, 1978

"Mr. T"
Big T Enterprises, Inc.
Beverly Hills, California
Breakfast cereal, 1984

"Mr. Whipple"
Proctor & Gamble Corporation
Cincinnati, Ohio
Toilet tissue, c. 1975

"Mr. Big"
Gardner's Drive-In Sandwich Stand
Fort Wayne, Indiana
Hamburgers, 1954

"Big Daddy"
Big Daddy's Enterprises, Inc.
Brooklyn, New York
Hamburgers and hot dogs, 1964

"McCoy"
McCoy Corporation
San Marcos, Texas
Paints, 1966

"Willie" Wilco

"Willie Wilco"
Wilco Distributors, Inc.
Lompoc, California
Poison bait for vermin, 1987

"Don Tomas"
Don Tomas Products, Inc.
Chelsea, Massachusetts
Rice, pasta and spices, 1974

"Pozo Pete"
Cattaneo Brothers, Inc.
San Luis Obispo, California
Beef jerky, 1977

"Pacific Pete"
Pacific Pete Company
Phoenix, Arizona
Restaurant services, 1980

Gold Shield Foods, Inc.
Monticello, New York
Frozen confectionery, 1980

"Skoal Bandit"
United States Tobacco Company
Greenwich, Connecticut
Smokeless tobacco, 1982

"Skookum"
Skookum Packers Association
Seattle, Washington
Washington apples, c. 1925

"Marathon Indian"
Marathon Electric Mfg. Company
Wausau, Wisconsin
Electric motors, 1960

"Atlanta Brave"
Atlanta Braves, Inc.
Atlanta, Georgia
Athletic events, 1969

"Cleveland Indian"
Cleveland Indians, Inc.
Cleveland, Ohio
Athletic events, 1974

St. John's University
Jamaica, New York
Athletic events, 1974

"Mark Elliot"
Chalme, Inc.
New York, New York
Shirts and sweaters, 1980

"Jolly Roger"
Jolly Roger Tobacconists, Inc.
St. Thomas, Virgin Islands
Smoking pipes and tobacco, 1962

"Pittsburgh Pirate"
Pittsburgh Athletic Company
Pittsburgh, Pennsylvania
Sporting goods, 1974

"Tampa Bay Pirate"
**Tampa Bay Area
NFL Football, Inc.**
Tampa, Florida
Football games, 1975

"The Oilzum Kid"
The White & Bagley Company
Worchester, Massachusetts
Lubricating oils, 1906

"Alfred E. Neuman"
E.C. Publications, Inc.
New York, New York
Magazine, 1955

"Sarge"
Ewing's Auto Parts
Richmond, Virgin
Automotive parts, 1968

"Dr. Wild"
Edison Brothers Stores, Inc.
St. Louis, Missouri
Shoes, 1976

"Crazy Eddie"
Crazy Eddie, Inc.
Brooklyn, New York
Retail audio store services, 1975

"Daffy Dan"
Daniel R. Gray
Gates Mills, Ohio
Clothing, 1976

"Crazy Benzy"
Crazy Benzy's #1, Inc.
Royal Oak, Michigan
Electric power tools, 1983

"Ralph Rotten"
Ralph Rotten's Nut Pound, Inc.
Centereach, New York
Retail nut sales, 1983

"Noid"
Domino's Pizza, Inc.
Ann Arbor, Michigan
Pizzas, 1988

"Budman"
Anheuser-Busch, Inc.
St. Louis, Missouri
Beer, 1969

"Captain Jimmy"
Warner-Jenkinson Company
St. Louis, Missouri
Food color, 1972

"Hungry Hero"
Hungry Hero Systems, Inc.
Greenwich, Connecticut
Restaurant services, 1977

"Captain Calorie"
Weight Wizards, Inc.
Norwich, Vermont
Weight control programs, 1978

"Captain Photo"
Photo-Magic, Inc.
Los Angeles, California
Cameras, 1981

"Dyna-Maid"
Allan V. Brackett
Arlington, Virginia
House cleaning services, 1982

"Captain M"
Runglin Company, Inc.
Culver City, California
Soft drinks, 1984

"Mattress Man"
Intl. Sleep Products Assoc.
Alexandria, Virginia
Mattress sale promotion, 1988

"Dart Man"
Dart Drug Stores, Inc.
Landover, Maryland
Retail drug store services, 1988

"C.H. Guenther"
Pioneer Flour Company
San Antonio, Texas
Flour and corn meal, 1899

"Samuel F. Spohn"
Bickmore, Inc.
Hudson, Massachusetts
Expectorant for horses, 1877

"William and Andrew Smith"
F & F Laboratories, Inc.
Chicago, Illinois
Cough drops, 1927

"Robert Burns"
Culbro Corporation
New York, New York
Cigars, 1931

"His Majesty Gustaf"
Stromstad Canning Company
Varvet, Sweden
Sardines, 1938

"Sir Thomas Lipton"
Thomas J. Lipton, Inc.
Englewood Cliffs, New Jersey
Tea bags, 1947

"Uncle Ben"
(Frank C. Brown)
Uncle Ben's, Inc.
Houston, Texas
Rice, 1952

"Sir Walter Raleigh"
Brown & Williamson Tobacco Corp.
Louisville, Kentucky
Cigarettes, 1959

"The Alaska Eskimo"
Alaska Airlines, Inc.
Seattle, Washington
Air transportation services, 1977

"Charlie Chaplin"
Bubbles, Inc. S.A.
Fribourg, Switzerland
Educational card game, 1972

"Telly Savalas"
International Trends, Ltd.
New York, New York
Men's clothing, 1977

"W.C. Fields"
W.C. Fields Productions, Inc.
Los Angeles, California
Ventriloquist dolls, 1980

"Wally Amos"
**Famous Amos Chocolate Chip
Cookie Corporation**
Van Nuys, California
Cookies, 1975

"Orville Redenbacher"
Hunt-Wesson Foods, Inc.
Fullerton, California
Popcorn, 1979

"Jack LaLane"
Jack LaLane Health Corp.
Beverly Hills, California
Candy bars, 1978

"Sam Behr"
Allied Tire Sales, Inc.
Altamonte Springs, Florida
Automobile tires, 1980

"Pee Wee Herman"
Paul Rubens
Studio City, California
Party goods, 1988

"Einstein"
Jaffe-Benshea, Inc.
Santa Barbara, California
Restaurant services, 1983

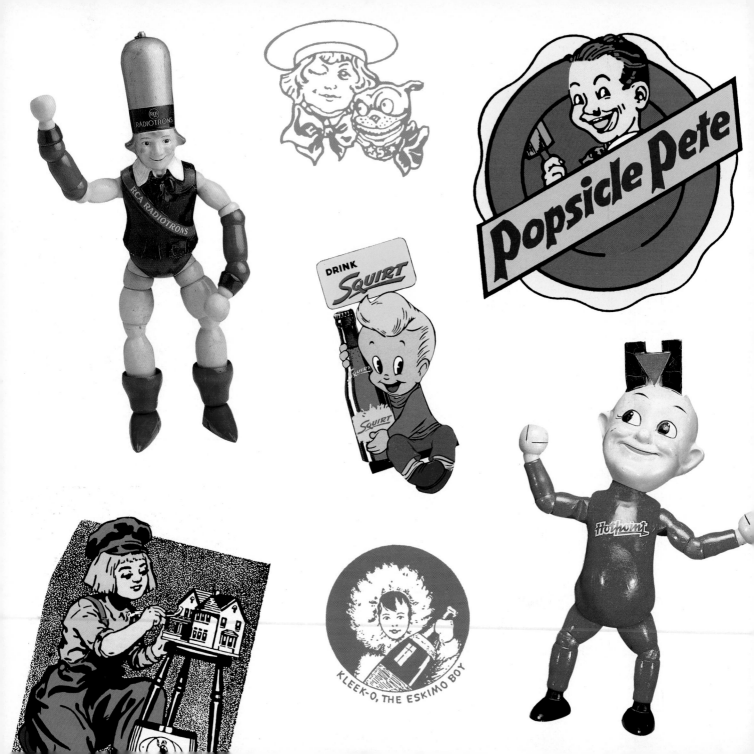

Popsicle Pete

DRINK SQUIRT

RCA RADIOTRONS

Hotpoint

KLEEK-O, THE ESKIMO BOY

Child Character Marks

Innocent or impish, children have always delighted the public as trade characters. One of the most beautiful, dating from the 1920s, is the *RCA Radiotron Boy* designed by Maxfield Parrish. Wearing a gold radio tube as a hat, he appeared as a wood-jointed doll in advertising and point-of-purchase displays. Held taut by string, this sixteen-inch poseable figurine was given slotted hands to hold promotional signs on counters and in window displays. Other early trade characters, including the pudgy *Hotpoint Boy* and *Bandy*, the General Electric bandleader, were also made into wood-jointed figures.

Another memorable child "star" who gained enormous popularity in the 1920s was *Cracker Jack*, the sailor boy. He and his dog Bingo sold molasses-coated popcorn, while his more obscure sister *Angelus* advertised marshamallows. *Buster Brown*, a cartoon character, was created in 1902 and licensed to a variety of manufacturers for use on their products. The Brown Shoe Company of St. Louis purchased rights to Buster and his dog *Tige* in 1904 and are still using the trademark today.

The Fisk Boy ("Time to Re-Tire"), which debuted in ad campaigns for Fisk tires in 1914, is another classic. Fifteen years later, B.F. Goodrich's French division introduced *La Gomme*; the sleepy child holding a candle was modified to a French youth wearing a beret. Unquestionably the most widely seen and used child character mark is the *Morton Salt Girl*. Created by the N.W. Ayer advertising agency to promote the Morton Salt Company's pour spout container, she first appeared on the package in 1914. Promoting the fact that salt runs even in damp weather, the little girl holds an umbrella in one hand while a container of salt pours out behind her. The tag line, "When It Rains It Pours," is the perfect double entendre. While the Morton Salt Girl has been updated over the years, she remains one of the great icons of American trademark design.

Clockwise from top left: the *RCA Radiotron Boy,* Radio Corporation of America, for radio tubes, c. 1935; *Buster Brown* and *Tige,* Brown Shoe Company, for shoes, c. 1930; *Popsicle Pete*, Joe Lowe Corporation, for toys, 1939; *Hotpoint Boy,* Hotpoint Corporation, for gas ranges, c. 1935; *Kleek-o the Eskimo Boy,* Cliquot Club, for ginger ale, 1929; *Dutch Boy,* National Lead Company, for paint, 1923; *Lil' Squirt,* Squirt Company, for soft drinks, c. 1955.

"Cracker Jack and Angelus"
The Cracker Jack Corporation
Chicago, Illinois
Confections, c. 1920

"The Campbell Soup Kid"
Campbell Soup Company
Camden, New Jersey
Soups, c. 1920

"Winthrop Wise"
Boston Varnish Company
Boston, Massachusetts
Floor enamel, c. 1920

"Messenger Boy"
Whitman's Chocolates
Philadelphia, Pennsylvania
Boxed chocolates, 1921

"Calumet Kid"
Calumet Baking Powder Company
Chicago, Illinois
Baking powder, c. 1920

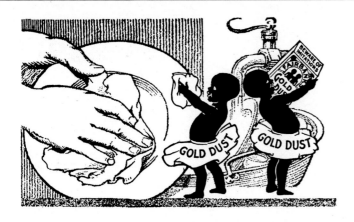

QUALITY TOILET PAPER PRODUCTS

"The Gold Dust Twins"
Gold Dust Corporation
Chicago, Illinois
Scouring powder, c. 1920

"A.P.W. Paper Dolls"
A.P.W. Paper Company
Albany, New York
Toilet paper, 1922

"The Clicquot Kid"
The Clicquot Club Company
Millis, Massachusetts
Ginger ale, c. 1920

 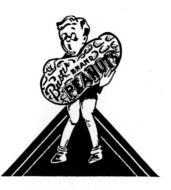

"Miss Freshway"
Freshway Products Company
Los Angeles, California
Ice cream and marmalade, 1936

"Buster"
Peanut Products Company
Des Moines, Iowa
Salted peanuts, 1938

"Miss Sunbeam"
Quality Bakers of America
New York, New York
Bread, 1942

"Chesty"
Chesty Foods
Terre Haute, Indiana
Potato chips, 1945

"Johnny"
Philip Morris & Co., Ltd.
New York, New York
Cigarettes, c. 1945

"Little Elpee"
The Bastian-Blessing Company
Chicago, Illinois
Welding equipment, 1948

"Tappan Boy"
The Tappan Stove Company
Mansfield, Ohio
Gas ranges and stoves, 1948

"Miss Dixie"
Dixie Dairy Company
Gary, Indiana
Dairy products, 1948

"Bowman"
Bowman Dairy Company
Chicago, Illinois
Milk and cream, 1947

"Frostee"
Thomas J. Lipton, Inc.
Hoboken, New Jersey
Powdered desert mixes, 1948

"Good Willy"
Goodwill Industries of America
Washington, D.C.
Philanthropic services, 1950

"Lil' Lulu"
The Morrison Drilling Company
Denton, Texas
Corn meal mix, 1953

"Angostura Boy"
Angostura Bitters, Ltd.
Port of Spain, Trinidad
Bitters for food flavoring, 1953

"Mohawk Indian Boy"
Mohawk Carpet Mills
Amsterdam, New York
Carpet, 1953

"Tropic-Ana"
Fruit Industries, Inc.
Bradenton, Florida
Fresh orange juice, 1954

"Frito Kid"
The Frito Company
Dallas, Texas
Snack foods, 1956

"Skilly"
The James S. Merritt Company
Kansas City, Missouri
Frozen confections on sticks, 1958

Catalano, Inc.
Fresno, California
Retail grocery store services, 1958

"Hi-Boy"
Fisher's Hi-Boy
Drive-In Restaurant
Springfield, Missouri
Restaurant services, 1953

"Brawny Lad"
Frisch's Restaurants, Inc.
Cincinnati, Ohio
Steak sandwiches, 1953

"Russ"
Russ' of Holland, Inc.
Holland, Michigan
Restaurant services, 1963

"Just Rite Girl"
J. William Corey
Crawfordsville, Indiana
Drive-in restaurant, 1964

"Big Boy"
Bob's Big Boy Restaurants
Glendale, California
Restaurant services, 1970

"Big Boy"
Bob's Big Boy Restaurants
Glendale, California
Salad dressing, 1985

"Miss Dairylea"
**Dairymen's League
Cooperative, Inc.**
New York, New York
Dairy products, 1958

"Hasbro"
Hassenfeld Brothers, Inc.
Central Falls, Rhode Island
Children's toys, 1959

"Mary Jane"
Charles N. Miller Company
Watertown, Massachusetts
Candy, 1960

"Jerry"
Jerrico, Inc.
Lexington, Kentucky
Restaurant services, 1961

"Sioux Bee"
Sioux Honey Association
Sioux City, Iowa
Honey, 1961

"Eskimo"
Eskimo Pie Corporation
Richmond, Virginia
Frozen desserts, 1961

"Jolly Roger"
Jolly Roger Enterprises, Inc.
Columbus, Ohio
Doughnuts, 1962

"Farm Fresh Boy"
Farm Fresh Supermarkets
Norfolk, Virginia
Margarine, 1963

"Little Miss Dixie"
Lander Company, Inc.
Fort Lee, New Jersey
Toiletries for girls, 1964

"Woody"
Wood Country Bank
Parkersburg, West Virginia
Banking services, 1967

"Sleepy Boy"
Bedroom City
Anaheim, California
Retail furniture stores, 1968

"Earnie"
Life Insurance Co. of Virginia
Richmond, Virginia
Insurance services, 1968

"Yankee Doodle"
Yankee Doodle House, Inc.
Elmhurst, Illinois
Restaurant services, 1969

"Benny & Fitz"
American Benefits Corporation
Memphis, Tennessee
Life and health insurance, 1969

"Rocket Boy"
Rocket Electric Company, Ltd.
Republic of Korea
Dry cell batteries, 1969

"Wendy"
Wendy's Restaurants, Inc.
Columbus, Ohio
Restaurant services, 1970

"Frosty Boy"
Frosty Boy, Inc.
Adrian, Michigan
Restaurant services, 1970

"Junior"
Junior Food Stores, Inc.
Panama City, Florida
Groceries, 1971

"Grocery Boy"
Grocery Boys, Inc.
Port Orange, Florida
Retail grocery stores, 1971

"Bi-Rite Boy"
General Grocer Company, Inc.
St. Louis, Missouri
Retail grocery stores, 1972

"Kayo"
Kayo Oil Company
Chattanooga, Tennessee
Antifreeze, 1965

Snap, Crackle, Pop

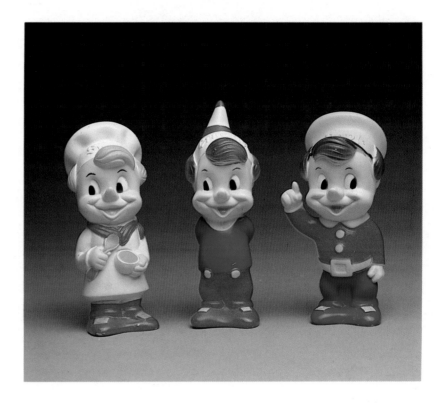

Snap, Crackle, Pop were created in 1941 as mascots for Kellogg's Rice Krispies; their names were derived from the sound the cereal made when milk was poured onto it in a bowl. Because the trio has been so successful in marketing Rice Krispies they have appeared on the cereal box, as well as in advertising, for fifty years. During the 1970s a variety of toys were manufactured which featured the whimsical trade characters, including the painted vinyl figures shown here.

"Rocket Boy"
Rocket Products, Inc.
Fenton, Missouri
Fruit-flavored drinks, 1974

"Bazooka Joe"
The Topps Company, Inc.
Brooklyn, New York
Chewing gum, 1974

"Lil' Red"
Red Steer, Inc.
Boise, Idaho
Restaurant services, 1974

"Super Baby"
Pregnant, Inc.
Rosemead, California
Children's furniture, 1983

"Léo"
Continental Sweets Company
Brussels, Belgium
Candy, 1983

"McBurglar"
McDonald's Corporation
Oak Brook, Illinois
Restaurant services, 1986

"Gerber Baby"
Gerber Products Company
Fremont, Michigan
Milk, 1988

"Swanky Franky"
Swanky Franky, Inc.
Laguna Niguel, California
Wearing apparel, 1988

"Bad Boy"
Life's A Beach, Inc.
Carlsbad, California
Skateboards and surfboards, 1989

"Little Miss Coppertone"
Plough, Inc.
Memphis, Tennessee
Suntan lotion, 1959

Bibliography

Campbell, Hannah, *Why Did They Name It...?* Fleet Publishing Corporation, New York, 1964.

Gordon, Neal, "Character Marks," *Executive Newsletter No. 32*, The United States Trademark Association, New York, 1981.

Jacobs, Karrie, "Identity Crisis," *Metropolis*, September 1987.

Morgan, Hal, *Symbols of America*, Viking Penguin, New York, 1986.

Smith, Clayton Lindsay, *The History of Trademarks*, Thomas H. Stuart, New York, 1923.

Your friendly Electrolux Man

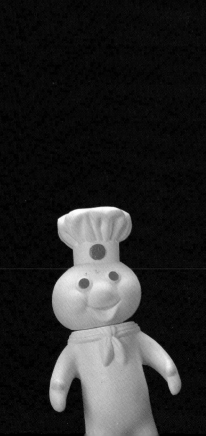

"He laughs best
who laughs last"